A GUIDE TO
HAUNTED
NEW ENGLAND

A Guide to
HAUNTED
NEW ENGLAND

Tales from Mount Washington
to the Newport Cliffs

THOMAS D'AGOSTINO

Haunted
America

Published by Haunted America
A Division of The History Press
Charleston, SC 29403
www.historypress.net

Copyright © 2009 by Thomas D'Agostino
All rights reserved

First published 2009
Second printing 2009
Third printing 2010
Fourth printing 2012
Fifth printing 2013

Manufactured in the United States

ISBN 978.1.59629.597.1

Library of Congress Cataloging-in-Publication Data
D'Agostino, Thomas, 1960-
A guide to haunted New England : tales from Mount Washington to the Newport
Cliffs / Thomas D'Agostino ; with photography by Arlene Nicholson.
p. cm.
ISBN 978-1-59629-597-1
1. Ghosts--New England--Anecdotes. 2. Haunted places--New England--Anecdotes.
3. Haunted places--New England--Pictorial works. 4. Historic buildings--New
England--Anecdotes. 5. Historic buildings--New England--Pictorial works. 6. New
England--History, Local--Anecdotes. 7. New England--History, Local--Pictorial works.
I. Nicholson, Arlene. II. Title.

BF1472.U6D334 2009
133.10974--dc22
2009033688

This book is dedicated to the New England traveler, from their foraging of paths to the creation of roads that lead to the scenic wonders and adventures that make the region so mysterious and alluring.

CONTENTS

Acknowledgements 9
Introduction 11

PART I: STUN IF BY LAND
White Mountains, New Hampshire:
 Where New England Legends Are Born 13
Burlington, Vermont:
 The Queen City Is King of Vermont Haunts 30
Berkshires/Mohawk Trail, Massachusetts:
 Too Scenic to Ever Want to Leave 41
The Quabbin, Massachusetts:
 Reservoir of Wraiths and Relations 64

PART II: BOO IF BY SEA
Mystic Seaport, Connecticut: A Ghost for Every Occasion 75
Newport, Rhode Island:
 More Ghosts than Anywhere Else in New England? 92
Salem/Marblehead, Massachusetts:
 More than Just Witches Brewing 110
Portsmouth, New Hampshire: Ghosts on Every Corner 123
York Village, Maine: Historical Haunting on Tour 138

Conclusion 155
Bibliography 157
About the Author 159

ACKNOWLEDGEMENTS

I am in deep appreciation of everyone who helped with the creation of this book. They all deserve a great mention and recognition for their knowledge of New England's rich history and folklore. Thanks to Joe Citro; Ron Kolek Jr.; Ron Kolek Sr.; the New England Ghost Project; everyone at Mystic Seaport; the York Historical Society; everyone in Berkshire Paranormal; Tiki and Betsy at the Eastover Resort in Lenox, Massachusetts; Harle Tinney of Belcourt Castle; Michael Cardillo Jr.; Robert Bankel and Evan Nickles of the 1833 House; Mandy Pincins and Justin Badorek; Dan Bidondi of the Valley Rangers; Matthew Moniz and Spooky Southcoast Radio; Cindy, Becky and everyone else at the Emporium in Mystic; Salem Night Tours; Chris Balzano; Jeff Belanger; Queen City Ghost Tours; Raymond Ducharme; Lisa Mears; Barbara Sheff; Su Wetzel; Roxie Zwicker; the Portsmouth Historical Society; Maggie Sherman; Tina Jordan; and everyone who wished to remain anonymous but were instrumental in making this book happen.

INTRODUCTION

New England is an enchanting land that draws to its borders people from around the globe. From the very first visitors to present-day vacationers, New England has something for everyone. The weather is ever changing, so there is never a dull moment, and the foliage is said to be the most spectacular in the world.

We New Englanders are proud of our heritage. Some of us are so proud that we refuse to move on after our mortal tenures on this earth. There are countless haunted places in this quaint region that my wife, Arlene, and I have visited. No matter how many we think we have found and investigated, more always seem to come our way. New Englanders love their ghosts, and there are more than enough to go around. People from Europe relish the opportunity to come here and witness some good old Yankee spirits.

In the following pages, you will find a select group of the most haunted destinations in New England. Full of ghosts and legends, these are places that the public can actually visit, where travelers can spend the night or sate themselves with food and spirits of all kinds. New England ghosts can be found everywhere in the region, and this book is hard proof of that. Some places we were able to investigate, while others were crowded or in their prime hours when we visited, but that does not mean you will have to pass on bringing a camera and recorder and asking the spirits a few questions of your own.

This book is designed to help the traveler arrive at the haunted destinations of cities and towns rather effortlessly. That is one reason Arlene and I chose the particular locations contained within. In some cases, a small drive or two may be required, but you will not have to spend half the day looking for parking to see one site. Many of the haunted sites contained in these municipalities are within walking distance of one another. Also included

are places to stay and eat that may not be haunted, as well as interesting activities for those who might want to take a moment from the ghost trail to try something different.

There may be some places within these localities that have been written up in other articles, books, periodicals or websites as being haunted. If these sites do not appear within these pages, it is because their owners have requested that they not be listed. Please respect all rules and regulations regarding the locations you visit. Good luck and many happy haunts!

Author's Note: Places marked with an asterisk (*) are those that Arlene and I have investigated either by ourselves or with others. To read more on the actual encounters, go to www.nepurs.info, where the investigations and findings are given in detail.

STUN IF BY LAND

WHITE MOUNTAINS, NEW HAMPSHIRE
Where New England Legends Are Born

The White Mountains are among the most breathtaking of all mountain ranges in the world. Established in 1918, the White Mountain National Forest covers 1,225 square miles of land full of fun and adventure. It is evident that the Native Americans knew the land was magical, as twenty-one Paleo-Indian sites have been discovered, some dating back ten thousand years. European exploration began in the mid-seventeenth century, but settlement did not occur until after the Revolutionary War, when people cleared the land for farming and formed little villages. As the nineteenth century bore on, many of these farms and villages were abandoned due to advances in farming techniques and the open spaces in the West providing for larger farms. Recreation in the mountains began around the early nineteenth century as trails, shelters, summer homes, resorts and ski slopes began to pop up everywhere. This aspect of the White Mountains has become the main draw of countless numbers of people each year. There are attractions of all kinds to enjoy, and then there are the ghosts.

The legends and tales that have emanated from this weird and wonderful place are often outlandish, yet by all accounts, they are said to be true. Some stories have detailed writings that prove their validity, while others have been handed down through the years by word of mouth. Some tales refer to places in the White Mountains that can still be visited, and some are of people who

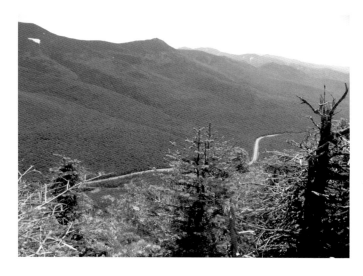

One of the many legendary notches in the White Mountains where strange legends and lore await.

have long since passed but have shaped the very framework of the region's folklore, making this area so mysterious and alluring.

The places and stories in this section have been arranged to take the reader along a circular route, beginning at a southerly position and working back to the starting point in Woodstock.

BENTON
Mount Moosilauke's Eternal Wanderer

Lightning streaks across the mountain peaks as pelting rain and thunder make it impossible to talk at a lower volume than a shout. The Ravine Lodge sways in the heavy wind as the squall takes on full fury. This is the perennial scene of a storm in the White Mountains. There is another perennial figure that is still spied along the peaks and fissures near Benton, New Hampshire: a man named Dr. Thomas Benton.

What makes the appearance of Dr. Benton so terrifying is the fact that he was born in the early 1800s. In fact, his family was one of the first to settle the area in the late eighteenth/early nineteenth centuries. The town of Benton was originally named Coventry but was later renamed in honor of Missouri senator Thomas Hart Benton, not to be confused with Dr. Benton, the main character of this narrative.

Young Benton grew into Squire Benton, and his intentions of practicing medicine were more than sincere. The community banded together and funded

his education on the stipulation that he would return to become the town's first and only doctor. While studying medicine in Germany, he became close friends with a Dr. Stockmayer. When Thomas Benton returned to his hometown as a full-fledged doctor of medicine, he brought with him a large trunk that had been willed to him by his friend in Germany. Its contents were believed to contain everything needed to complete experiments on an elixir of youth.

Benton soon met the love of his life and became engaged to marry. All seemed to be going well for the young doctor until his fiancée died of typhoid fever. The blow was devastating to the young Benton, and he became a bit mad. He stole away to the mountains, where he built a cabin on the top of Mount Moosilauke. There, it is said, he began experiments with an elixir of youth.

The young doctor completely disappeared from the community. Not too long after his departure, local farmers began to notice that their livestock was either disappearing or found dead under mysterious circumstance. When examined, it was discovered that the only mark on the animals was a bizarre red swelling with a white pinprick behind the left ear. The farmers deduced that it might be the elusive doctor performing some kind of experiment on their animals.

Some of the local farmers gathered together and ascended the mountain in hopes of finding out once and for all what the doctor was up to. Once inside the doctor's cabin, they found strange apparatus and the remnants of some recent experiment, but no doctor. They began to descend the peak, but darkness set in and one of the men became separated from the rest. The next day, the poor soul was found dead of mysterious causes. The only mark on him was strange swelling and a pinprick behind his left ear.

Soon, stories began to circulate that babies from nearby towns were mysteriously disappearing during their slumber hours. The people of the region feared that the doctor was stealing them for his evil experiments. One day, a woman was in her yard when a man with long white hair and a black cloak ran up to her young daughter and snatched her away into the woods. A band of men led by the child's father followed the footprints in the snow along Tunnel Ravine to a cliff. There, they found Benton high above them on a ledge and demanded that he release the girl, which he promptly did—to the ravages of the rocks below. After that, he was never seen again.

In 1860, the Prospect House was built at the top of Mount Moosilauke. People were afraid to bide their time at the hostel, despite the fact that the evil doctor had not been seen in thirty years. Fears were substantiated when a cable holding the house in place was cut by hand. A logger volunteered to repair the truss but never returned. He was found dead a short time later, with red swelling and a pinprick behind his left ear.

By 1881, the building had been expanded and renamed the Tip Top House. People began to stay there, feeling that Dr. Benton was either too old to do anyone harm or had long since passed. Still, there were frequent reports of a dark shadow in a cloak seen scuttling through the trees.

In 1920, the house was given to Dartmouth College, which ran it as an Appalachian Mountain Club (AMC) hut. It burned down in 1942, but the stone foundation remains. Of course, the doctor was blamed for this incident. There is another concrete foundation just below the remains of the Tip Top House. This was another AMC hut that was dismantled for safety reasons in 1978, although no one has divulged what those safety reasons were.

Reports of a mysterious dark form roaming around the mountaintop in period clothing are still broadcasted to this day. In 2003, a hiker spied an old-style boot print in the mud on a trail near the summit of Mount Moosilauke that had not been used for many years. Not only did the print belong to a boot that had not been worn for more than a century, but also the print had not been there moments before, and the hiker had not seen anyone go by him. Some have glimpsed the shadowy figure as it bounds through the thicket. Those who believe it is Dr. Benton swear that he has not aged a day in centuries. If it is the evil doctor, he may have found the secret of eternal life and is now a hermit of the mountains, or perhaps he is in search of a bride.

Mount Moosilauke is located between Benton and North Woodstock. Take Exit 32 off Interstate 93. Turn right onto Route 112 West. Travel about 3.0 miles to Route 118 and turn left onto that road. Continue 7.2 miles to Ravine Road and turn right there. Travel to the end of the road and reverse direction in the turnaround. Drive back down and find a parking space on the right side of the road closest to the lodge without blocking the roadway. The trailhead to the summit can be reached from here. The Ravine Lodge is located at the eastern base of the mountain. Guests enjoy a view of the mountains and satisfy their appetites with family-style meals.

The Coppermine Trail
Hike but Do Not Settle Down

About a mile or so north of where the Old Man of the Mountain once watched over the territory there is an abandoned trail where about fifty homes, a store, a church and even a school once sat. The buildings are long gone; uninhabited for over two centuries, the land has long since reclaimed them. Adventurers down this trail might spy a cellar hole reaching out from

the brush or a remnant of timber that was part of a wall. This was once a thriving community, but because residents did not heed the warnings of the Great Spirits, the town thrives no more.

About 1859, settlers migrating to the area discovered a vein of copper running through the rocky precipices. It was not long before prospectors zeroed in on the area of potential wealth and began laying out a town and railroad tracks to haul the copper down the mountain. The workers began to erect homes for the miners and their families, but something very eerie was going on. When they would resume their tasks in the morning, they would find that the previous day's construction had been undone. Foundations had been filled in or roofs completely removed from the homes. The oddest thing was that no one in the camp ever heard a noise.

People started moving into the finished homes, and the store, school, blacksmith shop and two churches went up without incident. Townsfolk began to notice Indians carefully watching their progress from just outside the perimeter of the little village. One day, the pastor of the town asked one of the natives what was going on and was told that they had built their homes on the burial ground of the Indians' ancestors and great chiefs. It was imperative that they move their town a few hundred yards away or suffer the fate of the Great Spirits, who watched over the burial ground. The roofs' being lifted from the homes was a warning to the White Man to move his village.

The pastor asked why the churches had not been touched by the infinite power of the Great Ones, and the Indian replied that the Great Spirits did not want to impede on the settlers' sacred places as a sign of mutual respect. The settlers, he said, should do the same and move. The people were not about to listen to native mumbo jumbo, and the town was completed and settled, in spite of the Indian's entreaties.

It was a hot day in August 1859 when travelers of the notch heard a thunderous roar from above. The sky over the village turned blood red, and a cloud resembling a great hand came down from the heavens into the mountains. Older Indians recalled that fateful moment well into the twentieth century.

Many living around the notch made haste toward the village but were taken aback by what they saw. Smoke billowed from the fireplaces and tables were still set with half-eaten plates of food, yet not a living soul remained. All of the men had perished in a massive collapse of the mine, and the families around the mine had choked on the heavy copper dust that blanketed the air. There was no sign of any living creature, human or animal. Many of the residents had just vanished, never to be seen or heard from again.

The mining company made an attempt to reopen the mine, but the White Man had learned that the power of the Great Spirits was not to be scoffed at. In time, the buildings began to decay and crumble as the earth reclaimed its post in the mountains.

The Coppermine Trail is open to hikers, but settling there is not a good idea. The trail is located off Route 116 in Franconia. Take Interstate 93 to Exit 32, Route 112, Lincoln/ Woodstock. Stay straight on Route 112 at the intersection of Route 3. Follow Route 112 to Route 116 and bear right onto Route 116. The trailhead will be on the right.

FRANCONIA
Sugar Hill Inn

Strange tales of the White Mountains have made them one of the most mysterious and charming places to visit. Laced among the countless attractions are the scores of legends that have forged the very alluring charisma the region holds. The Sugar Hill Inn is no different. The Oakes family came to Franconia in 1789. They built a farmhouse and planted crops. The house, with its post-and-beam construction, wide pine floors and ornate trim, was elaborate for farmhouses of the times. The floorboards are over two feet wide, as there were still plenty of tall trees in the region when it was built.

The house changed hands only one time before the Richardsons acquired it in 1925. In 1929, they built a large addition onto the existing house and opened a hotel called the Caramat Inn. That same year, an Austrian-born skier named Sig Buchmayr started America's first ski instruction school in Franconia. Although Beckett's-on-the-Hill sponsored the school, many still flocked to the Caramat for lodging, as the area was quickly becoming a popular tourist stop. During the 1950s, the successful Caramat Inn added three small cottages to accommodate tourists. In 1972, the name was changed to Sugar Hill Inn, where guests and ghosts together enjoyed the wonders of the White Mountains.

In one ghostly incident, an elderly couple entered the inn and exited through a set of closed doors to the right while guests looked on in astonishment. It is believed that they had been regulars of the inn a long time ago and were returning to their favorite getaway spot once more. The silhouette of a male figure is often seen in the kitchen, where the original owner of the house, Mr. Oakes, passed away.

The spirits of the inn are not harmful by any means; they just seem to like the atmosphere. The seven-room main house and six-room cabins

have breathtaking views of the Presidential Range. Some have fireplaces, in front of which one may relax as the flames take the chill out of the cool mountain nights. New owners Judy and Orlo Coots take extra measures to ensure that their guests have an awe-inspiring stay at the inn—even the permanent ones.

The Sugar Hill Inn (603-823-5621) is located on Route 117, PO Box 954, in Franconia, New Hampshire. Take Interstate 93 to Exit 38. Take a left at the stop sign. Bear right onto Route 18 into Franconia. Bear left onto Route 117; the inn is a half mile uphill on the right.

BRETTON WOODS
The Mount Washington Hotel Where the Princess Still Takes Care of Her Guests

The Mount Washington Hotel has changed hands several times over the past century, but there is one former owner who has never relinquished her duty of watching over the guests of the hotel. She is affectionately known as the "Princess"—and with good reason. Carolyn Foster not only dressed and carried herself as elegant as royalty but also, in her later years, actually married into it. Her father was a prominent meat merchant, and the family summered at the Twin Mountain House, where his choice cuts were a feature on the menu. Carolyn met the owner of the Mount Pleasant House, Joseph Stickney, and before long they were married. Stickney had made his fortune in coal and the railroads. They traveled the world together, spending their summers at the Mount Pleasant House. He had dreamed of owning another hotel in the White Mountains, and that dream came true when the Mount Washington Hotel opened its doors on July 28, 1902.

The hotel was Spanish Renaissance Revival and offered panoramic views of the mountains. The porch, one-sixth of a mile long, was almost as stunning as the appointments throughout the grand lodging. It was truly a magical place that became known the world over for its magnificent architecture and modern amenities.

Guests were treated like royalty. They would assemble for dinner in their best attire, and then Carolyn would make her grand entrance dressed the most elegantly of all. The guests were always astounded by her knack for outdoing everyone; they never knew that she had a secret curtain where she could spy on the throng before setting up her evening wardrobe.

Carolyn always brought her own bed when she traveled. It was a four-poster of ornate hand-turned maple, and the couple had it assembled wherever they stayed. Unfortunately, Joseph died in December 1903 at the age of sixty-four. Carolyn had a stone chapel built as a memorial for her beloved husband. The Stickney Memorial Chapel still stands to this day. Ten years later, she met a French prince by the name of Aymon Jean de Faucigny-Lucinge. They were married at London's Westminster Cathedral in July 1913. The couple ran hotels in Switzerland and France, as well as New Hampshire. Staff at the Mount Washington Hotel got a thrill out of calling Carolyn a princess. In August 1922, she became a widow once more. She remained fully involved in the hotels, spending summers at the Mount Washington Hotel, making sure her guests were treated second to none.

Carolyn died in 1936, leaving the hotels to a Harvard graduate and Hospital Trust banker named Reynolds. He had the Mount Pleasant House razed but kept the Mount Washington until it fell into shambles and closed in 1942. After several other unsuccessful attempts at running the hotel, a group of New Hampshire businessmen bought and reopened it in 1991. In 2001, it became a year-round venture. It seems that the princess has never stopped working there, as witnessed by guests and staff alike.

The apparition of a woman in fine Victorian dress is often spied gliding down the hallways where the guest rooms are located. Guests also have heard a slight rap on their door, and upon answering it, they have found no one there. The most active of all rooms is number 314. This is where the princess's hand-turned maple bed now resides. Many guests have been roused from a sound sleep by the sensation of someone sitting on the edge of the bed. Some have even seen the ghost of Carolyn, brushing her hair and looking out into the void of night. Those who have experienced Carolyn's presence were not at all scared and did not feel threatened. She is there to make sure that everyone is still getting the attention they deserve at a place that continues to be magical.

The Mount Washington Resort at Bretton Woods is located on Route 302. Take Interstate 93 to Exit 35, Route 3 North, to Route 302 East.

MOUNT WASHINGTON
A Ghost Story

Mount Washington was the first to have a Tip Top House, just before Mount Moosilauke. Adventurers would travel from the Glen House at the base of Mount Washington up to the Tip Top House, where they could spend the

night marveling at some of the most magnificent scenery New England has to offer. People from all walks of life took the opportunity to travel the path or rail that led to the top. There have been many hikers over the centuries who have braved the elements. Some have been lost to the merciless mountain. It is no wonder that there might be a few spirits lingering along the peak of New England's highest elevation.

One tragic story took place on September 14, 1855, when twenty-three-year-old Lizzie Bourne left the Glen House with her cousin, Lucy Bourne, and uncle, George, to climb the mountain at about 2:00 p.m. Due to their late start, they did not arrive at their destination before nightfall. A fierce gale struck the region, and the three took shelter behind some rocks. By about 10:00 p.m., Lizzie had succumbed to the ravages of the storm. It is also thought that she had a heart condition that contributed to her demise. As the sun rose over the peaks, Lucy and George saw that they were only a few hundred yards from the summit house. Lizzie was buried at Hope Cemetery in Kennebunk, but a crude stone monument was erected to mark the spot where she died. In time, the pile of stones was replaced with a more modern inscribed marker.

There is a well-founded tale that on September 14 of every year the ghost of Lizzie Bourne can be seen floating about the marker where she met her demise. Many years ago, one group of hikers chose to test the legend on a moonlit night. They arrived at the Bourne monument and sat down, talking about the incident. Soon, the clouds began to obscure what little moonlight there was. As they rose to head back to the hotel, one of the men shrieked in horror and pointed toward the monument. The group turned and saw a glowing figure rising from the stones. The misty figure took the form of a young woman with a sad face and flowing robes. She pointed toward the Tip Top House and then silently glided to the ground, where she lowered herself to her knees in prayer before fading away in front of the frightened throng. The moon shone bright on the peak once again, and the hikers stood alone at the monument, silent and stunned by what they had just witnessed.

It is written that Lizzie still makes her appearance at that location on September 14 of each year, watching over the vast area known as the White Mountains. Perhaps she is eternally taking in the scenery that she never saw on that fateful evening so many years ago.

CRAWFORD NOTCH
The Willey House

There is a tale that echoes through the mountains to this day with the howling wind and the rumble of thunder. It is a true story that has not lost impetus in its incredible telling over the centuries; in fact, it is probably the most enduring legend of the White Mountains. When the sky turns black and the lightning begins to flash over the peaks, the people of the mountains remember the tale of one fateful night in 1826, when the Notch of the White Hills—the notch or pass of the White Mountains, now known as Crawford Notch—gave way in the most terrible storm the area had ever seen. They remember even more the story of the Willey House.

Nathaniel Hawthorne called the mountains surrounding the path "majestic, and even awful." Upon traveling through the notch, even to this day, one can see the awe-inspiring peaks that loom over the road as it winds sheepishly around the bases of these great mounds. Traveling the notch was an arduous task, and in the winter, when the snows covered the land, it was almost impossible. Accounts of brave souls attempting to cross the notch are related in Benjamin Willey's book *Incidents in White Mountain History*, which tells of how parades of dogsleds ventured through the crevice on their way to other parts of New England to trade their goods.

There were two homes on either side of the notch—Ethan Allen Crawford's on the northwestern end and his father Abel Crawford's to the south. In the middle, about six miles each way, there was a house built by Henry Hill in an attempt to attract business to the notch. There were a few visitors, but not enough to sustain a successful living, so Mr. Hill took to the hills and left the small inn to the elements. Ethan Crawford acquired the Notch House but saw no real advantage in having it as a business until Samuel Willey Jr. and his family entered the picture.

In the autumn of 1825, Willey, his wife, Polly Lovejoy, their five children and two farmhands, Dave Nickerson and Dave Allan, took to work on the abandoned house, readying it for the harsh winter ahead. The winters in the notch were brutal, to say the least, much more intense than what the Willey family was used to in nearby Bartlett. Then there were the ominous crags looming some two thousand feet overhead. Every so often, a rumble from a landslide would resound through the mountains. This made Polly and the children very uneasy, for the ledges overhead were dangerously unstable. Sam Willey was determined to make a go of it; besides, there had been a decent flow of customers that season who had braved the pass knowing that the good family was there to put them up.

Spring seemed to become absorbed by winter and summer in the notch. The snows melted with the heat of May and June, and the days were short due to the high overhangs that blocked out much of the day's light. This did not deter Sam Willey and his help from doing a good day's chores. In June 1826, Abel Crawford and a few other men were repairing the road when sudden heavy downpours forced them to seek refuge in the Willey home. Within moments of reaching the house, a landslide poured from the side of what is now called Mount Willey, 4,260 feet above sea level, down onto the property, just missing the barn and covering hundreds of feet of roadway. A second slide followed, creating panic in the Willey homestead. It was now apparent that danger loomed closer than they thought.

Polly grabbed her youngest and bade them to flee from the house, but the men calmed her and the screaming children enough to reason that the house was a safer place to be in the storm. When all was cleared, Sam Willey made a small camp with an overturned wagon on a hill beyond the home and kept a team of horses and a wagon ready at all times. Soon after, all was forgotten, and the family resumed their daily routine, despite the occasional stone that would break free from its perch high above and hit the roof of the house.

August 28 started like any other summer day. It was muggy and dry. There had been little rain over the last month, but that was about to change. By afternoon, the sky had begun to darken into a most sinister hue. Thunder began to clap, and lightning struck the mountaintops. This was no usual thunderstorm—the rain began to fall in buckets, and the thunder and lightning overlapped in multiple strikes on the peaks. The family held fast, reading the Bible until the last moment, when they heard the deafening rumble of the mountain coming down around them. That was probably when they fled from the house into the ravaging storm.

The next morning, devastation was all the eye could see. Both Abel Crawford's and Ethan Allen Crawford's crops were destroyed by water, as the Saco had risen over twenty feet above its banks. The hogs were swimming for all they were worth, and both families had lost a number of sheep. The first to come upon the Willey house was John Barker. He had braved the notch trail that now lay mostly under rubble and river to get to the house. He was relieved to see smoke swirling from the chimney. The land and buildings around the house were completely destroyed by a great landslide that had come down behind the house. The home had not been hit by so much as a rock due to a great boulder that split the slide in two just above the domicile. About twenty yards after passing the house, the slide rejoined on its path through the notch. As Barker entered the inn, he found that the water had risen into the parlor,

where a circle of chairs sat around a Bible opened to the eighteenth psalm. There were documents and money on the bar but not a soul around. Weary from his journey, he made a quick cold supper and fell asleep.

Sometime in the night, he was awakened by a low eerie moaning. Having no torch to investigate the source of the sound, he waited until dawn. Upon investigation, he found that an ox had been trapped in the timbers of the collapsed barn. He freed the animal and went on his way to the Abel Crawford property, where he figured the Willey family had fled. He was a bit taken aback when he found they were not there. A search party was organized and began to tear apart the area around the Willey house. On Thursday, three days after the storm, searchers found Dave Allen and Polly Willey. Sam Willey Jr. was found by the river a few days later, and Sally, the youngest child, was found the following Sunday, along with the oldest child, Eliza Ann. A week after the storm, David Nickerson's body was found about four feet from the area where the first bodies were recovered. He was the last to be found. The three other children were never found. Some speculated that they might have gone mad and wandered the woods for the rest of their lives like wild animals.

The Willeys were buried near the Bigelow place at what is now Intervale. The names of the missing children were carved into the headstone as well.

The site of the Willey House disaster of 1826. Note the ledge in the background that split the landslide. *Photo courtesy of Arlene Nicholson.*

David Allen was buried at Bartlett Cemetery, and the whereabouts of David Nickerson's grave is unknown.

There was a pile of stones that was first used as a rough marker for the family near the house. Every traveler through the notch set a stone on it and bowed his head. The house was reopened in 1844 as a rest stop once again. Nathaniel Hawthorne was en route to spend a night at the house in 1864 but passed away in his sleep at the Pemigewasset House in Plymouth. In 1884, Horace Fabyan repaired the house and built a two-and-a-half-story hotel next to it. The house was destroyed by fire on September 24, 1899. The only remaining evidence of the house is a small cellar hole and a boulder with a plaque marking the site with details of the tragedy. Also still visible are the massive depressions running down the mountainsides where the landslides came down. The story still echoes through the mountains when the clouds descend on the peaks and the thunder threatens to shake loose the very foundation of stone that holds these great hills together.

As of this writing, the exact ledge of rock that split the Willey slide in two has been rediscovered, cleared and marked. A path to the landmark will be cut so that tourist may see it up close.

The site of the Willey House is in Crawford Notch State Park on Route 302. Follow Route 3 and bear onto Route 302 toward the notch.

HART'S LOCATION
Notchland Inn, Where Ghosts and Lore Lodge

Harts Location is a quaint little mountain community at the southern tip of Crawford Notch. The Notchland Inn, according to Les Schoof, owner/innkeeper, is located on property once owned by Abel and Hannah Crawford. The couple ran one of the Crawford houses of the gorge during the time the Willey family lived in the notch. There were three houses, according to Les—one at the top of the notch run by Ethan Allan Crawford; one a few miles below that was run by his brother, Abel Jr.; and the present Notchland Inn. Les expressed to me that the dining room of the inn was once the Crawford's tavern.

Samuel Bemis took control of the property in the 1860s. Bemis brought the camera from Europe and became America's first landscape photographer, as well as a successful doctor. But before all of them settled on the land, a legend had already been planted there. A young woman named Nancy Barden tragically died on the acreage in the 1700s.

The present inn has breathtaking views of the mountains. The thirteen lavish and spacious guest rooms have their own fireplaces and private baths. The amenities and scenic vistas are enough to make a person want to stay forever.

According to legend, Nancy Barden was a servant girl working for a Colonel Whipple in Lancaster. There was a man working for the colonel as well. Nancy and the man fell in love and were to marry. Here is where the story splits into two versions. One version states that Nancy went into town to buy some wedding clothes. During her absence, the man took the wedding dowry and ran off. The other version claims that, for some reason, the colonel strongly objected to their marriage and sent the man to another farm.

Either way, Nancy came home to find her lover gone. She set out on foot through the notch in search of her betrothed. She came across a campfire and assumed that the man who had spurned her had been camping there, so she continued on. She came upon the property of the present Notchland Inn, where she fell into the icy stream and froze to death.

She was buried near the brook and pond that now bear her name. It is but a few minutes' stroll down a path to the cairn of rocks that marks her final resting place. There is a stone that also tells the story at the inn. On the stone reads the inscription: "Nancy, Who Died in Pursuit of Her Faithless Lover."

If the story of Nancy does not catch your fancy, perhaps the ghost of Abigail will. Some locals and guests say that a girl named Abigail haunts the inn. One couple claimed that a ghost named Abigail wrote her name on the mirror in their room. Les and his partner, Ed Butler, remembered cleaning the attic and coming across a letter from a mother to her daughter. The name on the paper was Abigail Jones. The innkeepers think this person may have been a servant of the Bemis family. The ghost is said to make herself known on occasion, but Les has yet to see her. "I guess I have not done anything to annoy her yet," Les said.

There is another graveyard on the property where Dr. Bemis and the Crawford family are interred. The history of the inn is spread out along the property, and if you're lucky, you might even get an opportunity to meet some of the inn's former inhabitants.

The Notchland Inn is located on Route 302 in Hart's Location. Take Interstate 93 to Exit 40, and follow Route 302 toward Twin Mountain. Continue on Route 302 past Twin Mountain into Hart's Location. The Notchland is located on Route 302.

Mount Chocorua
An Indian Curse Upon the Land

Mount Chocorua is one of the most, if not the most, striking of all the peaks in the White Mountains. Although it is the 100th highest peak, it hails as one of the most photographed, as its large bare summit is visible from all directions. This gives the mountain a much larger stature than its actual elevation suggests. One would not hesitate to say that the hill is magical, and one would be right, for the mountain has a legend attached to it that has been recanted through the ages.

Originally, the Pegwagget Indians lived in the region now known as Tamworth. They sided with the French against the British colonies in 1703 during Queen Anne's War and remained loyal to their new allies. In 1724, the Pegwagget attacked several British colonies, thus creating a bounty for every Pegwagget scalp collected. In 1725, Captain Lovewell and his men set out to remove the tribe from the area. Although they were not entirely successful, the Pegwagget people got the message, packed up their tepees and headed north. All but two Pegwaggets trekked to safer grounds. Chief Chocorua stayed behind with his son, Taumba. He taught his son that the land belonged to the Pegwagget and no white man would drive him off. Happily, he hunted the mountains and lived off the tribal land of his ancestors. He even befriended a white man by the name of Cornelius Campbell. Taumba enjoyed the company of Campbell's children, and they often visited one another.

One day, the chief was called away to a meeting with other tribal chiefs. Fearing that the long journey would be too much for young Taumba, he left his son in the care of the Campbell family. Taumba was a curious lad—a bit too curious for his own good. When Mr. Campbell mixed some savory poison to rid his farm of the wolves and fox that had been stealing his livestock, Taumba, thinking it was a new food sensation, ingested the concoction and died.

The distraught family buried the young boy on their property, and when Chocorua returned, they delivered the sad news of the boy's passing. Chocorua went into a fit of rage and vowed revenge. Not long after, Mr. Campbell returned from hunting to find that is wife and children had been slain. He knew too well who the culprit was and set out to find Chocorua. A lengthy pursuit led the two men to the top of the mountain that now bears the chief's name. Campbell raised his musket, but Chocorua, with nowhere to run, raised his arms to the sky and yelled out a curse. The exact words are lost to antiquity, but it went something to the effect: "May the Great Spirit

curse you when he speaks in the clouds and his words are fire. Lightning blast your crops, and wind and fire destroy your homes. The Evil One breathe death upon your cattle. Panthers and wolves howl and fatten upon your bones. Chocorua goes to the Great Spirit but his curse stays with the White Man." He then leaped over the edge of the cliff to his death. Another version relates that a band of men chased Chocorua up the mountain until they could follow no longer. From there, they set the trees aflame, scorching the whole top of the mountain. As the fire consumed the apex, Chocorua yelled his curse and jumped off the edge of the cliff. Either way, the end result remains the same.

Cornelius Campbell was found dead near his cabin almost two years later, his body partially eaten by wolves. Many believed in the powerful curse the chief had put on the area and refused to settle in the region for fear of losing their cattle, or more. Some time later, a strange malady killed scores of cattle. Although experts concluded that it was mud lime in the water that was killing the cows, mountain folk believed it was Chocorua's curse being fulfilled. Even today, the people of the mountains take stock in the words that once echoed across the mountaintops, letting the White Man know that the Great Spirits are watching over the Indians' land.

Mount Chocorua is located in the Sandwich Range. To find the trailhead, take Route 112 about eleven miles west of Route 16.

OTHER PLACES OF INTEREST AND ADVENTURE
The Flume Gorge

Franconia Notch State Park is home to the Flume Gorge and is ranked as one of America's top ten most beautiful state parks. The gorge was discovered in 1808 and extends eight hundred feet at the base of Mount Liberty. It is a natural chasm, twelve to twenty feet wide, with a walkway along the seventy- to ninety-foot ledge just above the water that ascends to the top of the granite edifice. Visitors pass through covered bridges and by waterfalls and bask in the natural wonder of the White Mountains.

Open from May 8 to October 26. Follow Interstate 93/Route 3 to signs for the Visitor Center and gorge. Call 603-745-8391 for information. There is a fee to enter the park.

Cannon Mountain Aerial Tramway

Once you have gone to the bottom of the mountains, you may want to hit the top. An eighty-passenger car takes visitors to the 4,080-foot peak, where the view of New Hampshire, Vermont, Maine, New York and Canada is breathtaking. There is an observation deck, a cafeteria, a bar and trails along the ridge, with striking views of Franconia Notch.

Cannon Mountain is located on Interstate 93/Route 3 at 9 Franconia Notch State Park. Call 603-823-8800 or e-mail info@cannonmt.com for more information. There is a fee for the ride on the passenger car.

Find the Lost River

In 1852, two brothers, Lyman and Royal Jackman, were fishing along a stream in Kinsman Notch. Lyman fell into a cave, now called Shadow Cave, and the Lost River was found. The two found several other caves, and before long, it was a tourist attraction. It is called the Lost River due to the fact that it disappears and reappears through the caverns and caves.

The Lost River is open from May 5 to October 26 with special Halloween tours on October 3 and 4. It is located at 1712 Lost River Road, Route 112, in North Woodstock. Call 603-745-8301 for more information. There is a fee to visit the attraction.

Clark's Trading Post

A trip to the White Mountains is not complete without a visit to Clark's Trading Post. The Clark family's trained bear show has been entertaining visitors since 1949. Included in admission are Americana museums, rides, haunted houses, gift shops, a White Mountain Central Rail Road excursion and the bear show. One small but interesting fact: the Clark Home across the street was relocated to that spot from the now abandoned village of Johnson in the 1950s. The remnants of the village are just north of the trading post amidst the thicket of the mountains.

Located on Route 3 in Lincoln. Call 603-745-8913 or e-mail info@clarkstradingpost. com for more information.

STAY ALONG THE WAY

Pemi Cabins
460 U.S. Route 3
Lincoln, NH 03251
603-745-8323 / 1-800-865-8323
www.pemicabins.com
*Fourteen rustic and inviting one- and two-bedroom cabins nestle on the bank of the Pemigewasset River. Some offer kitchens, fireplaces and screened-in porches overlooking the Pemigewasset River. All offer complimentary coffee, HBO and WIFI. Cabins with kitchens come fully equipped, and all of your linens are provided. They accept pets and are open year round.

Woodstock Inn and Brewery
135 Main Street
North Woodstock, NH 03262
1-800-321-3985
relax@woodstockinnnh.com
*The Woodstock Inn, Station and Brewery is a must while visiting the White Mountains. The inn's gracious and relaxed setting centers on thirty-three guest rooms, each individually appointed with cable TV, air-conditioning and in-room telephones. Grand rooms offer Whirlpool tubs and gas fireplaces. Accommodations include a hearty country breakfast. There is a restaurant, brewpub and gift shop as well. They also make their own famous beer on the premises and offer it for sale in growlers.

BURLINGTON, VERMONT
The Queen City Is King of Vermont Haunts

Burlington, otherwise known as the Queen City, is the largest city in Vermont, but it took awhile for it to actually become permanently settled. Burlington was one of the 135 New Hampshire grants awarded by Governor Benning

Wentworth. The governor named the grants after British landed gentry, and Burlington was named after Richard Boyle, Third Earl of Burlington. Samuel Willis and sixty-three other pioneers were awarded the grant on July 7, 1763, but it took about twenty years to clear and actually settle the land. Strangely enough, it was organized as a town in 1785 but did not become incorporated until 1865.

The first European thought to have spied the Green Mountains was Jacques Cartier in 1535, but it was famous French explorer Samuel de Champlain who actually claimed the land for the French on July 30, 1609, calling it *Les Verts Monts*, or "Green Mountains." Even Champlain had an unusual encounter with the supernatural of Vermont, or so it is told in his writings and later scholarly reports.

THE RESTAURANTS THAT THRIVE FOR THE AFTERLIFE
The Ice House

Burlington, Vermont, is located at the northwestern tip of the state along the famed Lake Champlain, home of "Champ," the lake's infamous sea creature. It is also home to many land-bound oddities and eerie places. One such place is called the Ice House, a noted restaurant and office building in the downtown area.

My wife's daughter, Amanda, and her fiancé, Justin, once lived in Burlington. Justin is a chef of very high caliber, so it was not long before he found himself working in a fine-dining establishment.

One day, as he was in the kitchen of the Ice House cleaning up, he spied someone out of the corner of his eye. To his amazement, he gazed upon a semitransparent apparition of an old lady swinging a bell. He immediately noticed that the bell made no noise whatsoever. At that point, he knew he was staring at an image from another place in time. As he approached the figure, it vanished as silently as it had appeared. The wraith has been seen numerous times by other employees as well. A cook who has been there for many years is so accustomed to the haunted place that it seems lonely to him without something happening regularly.

The staff on duty have often heard the distinct sound of ice blocks being dragged across the floor. The grinding sound becomes an eerie echo in their ears until the ghostly labor ends and silence once again prevails. The original structure was an icehouse. It is told that the great blocks of ice sliding or falling accidentally crushed many laborers. Some workers were badly maimed while

others died. It is no wonder the place harbors residual energy in the form of spirits not ready to leave their final earthly moments. Objects that are put down in obvious places tend to disappear, only to be later discovered hidden in strange nooks of the kitchen and basement. The long maze of corridors with their many intersections on the first floor, where the kitchen is located, often becomes a haven for apparitions. Many times, Justin encountered someone near the crossing of the vast corridors. When he stopped and looked again, the person was no longer there. The length of the passageways would not give anyone time to hide from plain sight.

The history of the structure is born of tragedy. John Winan, a Burlington shipbuilder, erected his home on the site in 1808. That year, he began construction of Lake Champlain's first steamboat. In 1868, fire claimed the home, but the location was ideal for holding ice from the lake. An immense icehouse was soon rebuilt from the foundation to serve the region of the lake.

The massive three-story building supplied ice year-round to the residents of Burlington for many generations, with the chunks cut from Lake Champlain. It remained in operation well into the twentieth century before being converted into retail property. The massive foot-square beams used to support the heavy ice still adorn the building.

If you are in the area of Battery and King Streets in Burlington, be sure to have a bite at the Ice House Restaurant.

The Ice House Restaurant (802-864-1800) is located at 171 Battery Street #1. Take Exit 14W onto US-2/Main Street and continue to the end of Main Street.

American Flatbread Company
Natural Food, Natural Spirits

American Flatbread specializes in natural, homemade everything. Slow-cooked sauces top its pizzas, along with fresh organic vegetables and other natural ingredients. Combine this with an unbelievable beer list and you have a dining and drinking place that keeps the crowds coming back for more. But there seems to be a permanent guest hanging around the establishment. It appears that an employee, before it was the flatbread company, took his own life in the basement. The ethereal encounters in the basement where the kitchen is and where the kegs for the bar are stored are enough to make the bravest seek safer ground. Glasses and plates fly off shelves, smashing in the middle of the floor. Doors

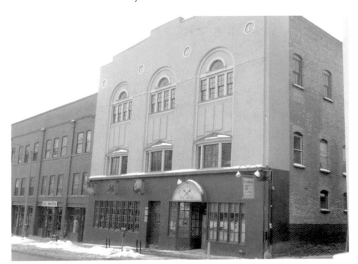

The American Flatbread Company in Burlington. *Photo courtesy of Vickie Julian.*

open and close, including the walk-in door where waitresses have been locked in. It seems the ghost likes to play games with the waitresses, so much so that they are advised not to venture into the basement alone. A widespread story concerns a bartender who had just finished washing and putting away the glasses behind the bar. She turned for a moment and heard a loud clinking sound. She reeled around quickly to find that the glasses had been arranged in a pyramid on the bar.

The American Flatbread Company was once home to Carburs Restaurant, where many stories circulated about the place being haunted. The name change and dissimilar menu have not scared the ghost away. If it is good enough for an eternal guest, imagine how you might feel after just a few visits.

American Flatbread Company (802-861-2999) is located at 115 St. Paul Street. Follow the directions to the Ice House but bear right onto St. Paul Street.

Vermont Pub and Brewery
The Restroom Wraith

The Vermont Pub and Brewery was established on November 11, 1988, making it the oldest craft brewery in the Green Mountain State and the second oldest on the East Coast. This fine brewpub always attracts a host of visitors eager to savor the unique nectars it has to offer. Unfortunately, a guest from

The Vermont Pub and Brewery sign in Burlington. *Photo courtesy of Joseph Citro.*

the other side reminds them that the libations are but temporary, as witnessed in the restroom when a spirit appears at the commode doing what others have entered the room to do. No one knows who this ghost is, but it is not a surprising addition to a brewpub that makes such a tasty array of crafted beers.

THE UNIVERSITY OF VERMONT
The Most School Spirit(s)

My wife's daughter and her fiancé lived in Burlington, very close to the University of Vermont. We would travel up to Burlington and stay the weekend, visiting Mandy and Justin while taking in the sights. It was during one of those trips that I heard about the many spirits of the University of Vermont, or UVM, as it is more commonly known. UVM is the acronym of *Universitas Viridis Montis*, the phrase that appears on the official seal of the college. The Latin translates to "University of Green Mountains," which was established the same year Vermont became a state, in 1791.

UVM was the fifth college to be established in New England, after Yale, Brown, Dartmouth and Harvard. Many prominent people hailed from this institute of higher education, such as John McGill, the leader of Doctors Without Borders when it won the Noble Peace Prize in 1999; John Dewey, famous for the Dewey Decimal System; and Hollywood producer John Kilik, who is known for such movies as *Malcolm X, Dead Man Walking* and *Do the Right Thing*. The list goes on and on.

We visited the campus on a Saturday in June and found it to be a very quaint, educational facility filled with ghost stories and history. Vermont author Joseph Citro investigated the university extensively and found no fewer than fourteen buildings that were either haunted or had some sort of strange events take place in them. The campus resembled a ghost town due to summer break but the spirits of the facility seemed to be eternally enrolled in the school. The following are some of the more interesting haunts that remain notable at UVM.

Converse Hall at UVM, where the ghost of a former student still makes his rounds. *Photo courtesy of Joseph Citro.*

Converse Hall on South Prospect Street was erected in 1895. It served as a dorm for the students at that time. In the 1920s, a despondent medical student committed suicide in the building. Some say it was the pressure of keeping up his grades that drove him to kill himself, while others claim he was a depressed individual with a weak spirit, unable to take on the rigors of medicine. Whatever the case, his spirit seems to have a lasting presence within the walls of Converse Hall. The ghost is named Henry. Whether that was his real name is a matter of conjecture. He is known for opening and closing doors and windows throughout the building. He also enjoys playing with the lights at all hours of the day and night. Students and faculty members have turned out the lights and left a room, only to see the glow of the lights suddenly emanate from the window or the crack at the bottom of the door. There is a report of a ghostly typewriter that once alarmed a student. The student was alone in the room when the sound of typewriter keys began tapping. Upon investigation, all typewriter desks were vacant in the room. The thought of some ethereal fingers trying to communicate through the typewriter scared the student so much that she left the room in frantic haste.

Furniture has a way of rearranging itself in empty rooms, and small objects will suddenly take on wings and sail through the air with no visible

hand to hurl them. Henry certainly keeps himself busy in Converse Hall, but he is not the only phantom on campus. The others seem to be in eternal competition for attention as well.

Another building of reputed haunts is the Counseling Center, located at South Williams and Main Streets. Unlike Henry, who would rather stay unseen, the ghost in this old mansion is not afraid to show his presence. Some say it is the spirit of Captain John Nabb, who built the mansion in the nineteenth century. Doors and windows slam on their own, and lights turn on and off. People have heard voices in the halls when they are completely empty. Several reliable witnesses describe the ghost as a man with thick sideburns and a bulbous nose. He also appears to be angry. One custodian watched in disbelief as the spirit passed by his cleaning bucket, overturning it onto the floor as it wisped down the hall. Maybe the captain is unhappy over the fate of his former home.

Old Mill is the university's oldest structure. It was built in 1824 after the original building was lost to a fire. People have experienced the sensation of being watched by unseen eyes. There is also ghostly activity on the second floor. The spirit of a lady has been seen in one of the old rooms. No one is sure who she is, though they think that she may have been a teacher at one time. The building was recently renovated, so the spirit may have been activated by the changes. Only time will tell.

The Public Relations building has a ghost as well. This spirit is said to be former owner John E. Booth. The Booth family owned the house from 1913 to 1967. Although he has stayed in the house, Booth is not much for public relations. He has never been seen, but his presence has been felt, and he does play with lights. He also likes to hold doors closed on people as they try to open them. He makes noise around the house on occasion by banging into items or letting his voice be heard.

The Bittersweet House at UVM, where the spirit of Margaret L.H. Smith has shown her presence since her death in 1961. *Photo courtesy of Joseph Citro.*

Some of the spirits have faded with time. Take the Wheeler House, for instance. The Reverend John Wheeler was the university's sixth president. The house was reputed to

be haunted by Wheeler's daughter, Lucia, who died in 1871 of tuberculosis. Some witnesses have seen the girl, and others have just heard her walking the halls at night when the house is otherwise empty. Over the years, the haunting has dissipated, and now her spirit is all but gone.

Grasse Mount was a building I found to be historically interesting, as well as paranormally tantalizing. The mansion, located at 411 Main Street, was constructed in 1804 for Thaddeus Tuttle. He later sold it to Vermont governor Cornelius Van Ness. It was the governor's wife who named it Grasse Mount. He later sold it, and after a few more transfers of deed, it came into the ownership of UVM in 1895. It now houses the Department of University Advancement, as well as a few residual ghosts. One time, a former employee was closing up the building for the night when the windows began to rattle and the pipes and ducts of the heating system began to rumble and bang. The system is shut down for the summer to conserve unnecessary energy waste. The employee took the noises as a suggestion to make a quick departure from the old mansion.

Another employee experienced the entities of the manor in a different light. Around the witching hour one night, the whole place became a playground for mischievous spirits. Doors began to slam, and footsteps were heard pounding up and down the halls. The windows and filing cabinet drawers rattled as if the earth itself was shaking. The frightened employee called security, but there were no visible beings in the building to create the disturbance. Recent renovations to the Grasse Mount have seemed to squelch the activity somewhat, but people in the building still feel the energy lurking in the shadows, waiting for another unsuspecting person to be caught in the building after the midnight hour.

The most fascinating building by far is the Bittersweet House, located at the corner of South Prospect and Main Streets. This one harbors the ghost of Margaret L.H. Smith. The house was built in 1809. It was named the Bittersweet House when Mrs. Smith's husband died in a car accident shortly after they bought their dream home. She stayed alone in the house right up until her death in 1961 at the age of ninety-four. She died in the house, and many swear that she still resides there. A few witnesses have seen the ghost of Margaret Smith walking through the halls dressed in a bell-shaped ankle-length skirt and a white high-collared blouse. Her hair is wrapped up neatly away from her neck. One employee of the house, which now is home to Environmental Programs, has seen the spirit on several occasions. Others have seen her as more of a glowing form and not as clearly defined in shape. Having a real ghost that appears frequently made this building the most intriguing of all the buildings on campus.

Take I-89 Exit 14W and travel one mile on Route 2 West to campus.

CHAMP
Vermont's Official Lake Monster

Perchance you might find yourself strolling along the banks of Lake Champlain while in Burlington. There are plenty of places to take in the lake's bountiful vistas and open waters. It may also occur to you that the long thin head sticking out of the water is not an ordinary lake creature.

Lake Champlain is 125 miles long, with depths up to four hundred feet. The Abenaki and Iroquois Indians of the region told many stories to the White Man of the lake creature. The Abenakis called it Tatoskok. Lake Champlain's resident creature, now known as Champ, has been spotted as far back as 1609, when Samuel de Champlain reportedly saw the Iroquois fighting with it on the bank of the lake. This account is largely based on an article that appeared in 1970. Since then, there have been over three hundred reports of Champ splashing around in the lake. The first actual written report of Champ was in 1883, when Sheriff Nathan H. Mooney saw a monster about twenty-five to fifty feet long in the water. His report predates the Loch Ness Monster sightings by fifty years.

The rage to witness Champ began. Ferries, steamers and commercial ships along the lake began to see the now famous Champ swimming about on occasion. P.T. Barnum offered $50,000 for the capture of Champ so he could include the monster in his show. The largest mass sighting of the creature occurred on July 30, 1984, aboard the sightseeing boat *Spirit of Ethan Allen*. The crowd was celebrating a wedding when the captain noticed something in the water about two hundred feet away. Everyone watched as the creature swam parallel with the boat, five humps protruding from the water. They estimated it to be about thirty feet long. It moved along with them until a speedboat approached. It then turned and retreated.

Sandra Mansi took a photo of the "monster" in 1977. Joseph Zarzynski, founder of the Lake Champlain Phenomena Investigation, stated that the photograph did not resemble any animal or creature that he knows of residing in or around the lake. Although he would love to see conclusive evidence, after researching and tracking the monster since the mid-1970s, he concluded that the picture could have been of a log or tree branch in the water.

The creature might be a plesiosaurus, the prehistoric fish thought to roam Loch Ness as well. It could also be a longnose gar, or garpike, which is also a prehistoric fish of the *Lepisosteus osseus* family. According to scientists,

the garpike has not changed in 180 million years. Many believe that if Champlain saw the Indians fighting a creature on the banks of the lake, it would have been the garpike. This fish has a very long snout with needlelike teeth resembling what might be thought of as a sea monster. The garpike is native to North America, so it would not be likely that Champlain had ever seen one before his arrival to the region.

Reports of Champ sightings continue to this day, but researchers and cryptozoologists are still looking for an actual monster that they can put their hands on or interview.

Lake Champlain is located on the western side of Burlington.

THE OFFICIAL TOUR

In Burlington, Vermont, Queen City Ghostwalk has been treating visitors and locals to a stroll on the spooky side of town since 2002. Tour owner and guide Thea Lewis says that Burlington's haunted history is particularly fascinating, and when you combine tales from the harbor, retail and industrial areas with creepy accounts from the University of Vermont just up the hill, you might consider Burlington the most haunted city in Vermont.

A favorite story for Lewis and her guests is that of the ghost of Edwin Parker, a volunteer firefighter in Burlington in the late 1800s. It is said that his ghost inhabits the old firehouse, where he spent his happiest days.

Edwin perished while fighting a blaze at the Holt Spool and Bobbin Company. He was crushed, his body doubled over, when a wall of brick rained down on him.

Not long after Edwin's untimely death, people began to experience strange things at the Ethan Allen Engine Company, home to Edwin's volunteer team. Firefighters swore that someone they could not see was watching them as they went about their duties. Some claimed to hear footsteps following them as they walked the corridors, even though they were alone in the building. Others reported hearing the sound of hoses being moved about in the drying tower, even though the tower was empty.

Today, the station has been converted to an art gallery, but employees and patrons still feel Edwin's presence. An elevator located in the space that once held the old hose tower likes to travel to the basement office floor after hours, without aid of human intervention, and pause there once the doors have opened as though someone is getting out.

Employees working late say it is as though some invisible co-worker is paying them a visit.

Burlington features many fine hotels and B&Bs, but for sheer ambiance and hospitality, nothing beats the Willard Street Inn. This inn was built in the late 1880s for Charles Woodhouse, a prominent businessman and Vermont state senator. The design of the house incorporates elements of the Queen Anne and Colonial Georgian Revival styles, both of which were gaining in popularity at that time.

From the hotels, guests can walk to Lake Champlain, art and cultural venues and shopping and restaurants in downtown Burlington, and on crisp autumn nights, they can enjoy a spine-tingling walk through Burlington's haunted history with Queen City Ghostwalk. Call 802-351-1313 or visit queencityghostwalk.com for more details.

Other Things Burlington But Not Boo

Church Street Marketplace is the pride of the Queen City, with four blocks of shops, cafés, restaurants, vendors, live music and places to sit and bask in the family-friendly atmosphere along the nineteenth-century art deco walkway.

Shipwreck Tours

Stay dry and still see 1800s shipwrecks using a robotic camera while enjoying a great boat ride on Lake Champlain. Historical and adventurous. Slip #35 at the Burlington Boathouse. Call 802-578-6120 or e-mail Rachael@ shipwrecktour.com for more information.

Spirit of Ethan Allen III

This is the largest cruise ship on Lake Champlain. It is 140 feet long and holds 424 passengers. It offers everything from sightseeing, brunch, entertainment, dinner and theme cruises. It is family friendly as well. The ship leaves Burlington Boathouse at 1 College Street. For more information, write to 348 Flynn Avenue, Burlington, VT, 05401, call 802-862-8300 or visit their website at www.soea.com.

Ethan Allen Homestead

Offers guided tours of the famous statesman's home, including walking trails and scenic vistas of the Winsooki River. Located on Route 127 in Burlington. Call 802-865-4556 or e-mail info@ethanallenhomestead.org for tour schedules.

A Place or Two to Stay

One of a Kind Bed & Breakfast
53 Lakeview Terrace
Burlington, VT 05401
1-877-479-2736
www.oneofakindbnb.com
*A very friendly, charming place that has bright, warm energy. Guests feel the wonder that lingers in the air of this clean and welcoming place.

Willard Street Bed and Breakfast Inn
349 South Willard Street
Burlington, VT 05401
1-800-577-8712
www.willardstinn.com
*An 1881 brick and white marble Victorian with fourteen guest rooms, a short walk from all the Burlington boos.

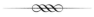

Berkshires Mohawk Trail, Massachusetts
Too Scenic to Ever Want to Leave

After the French and Indian War of 1750, the Massachusetts Bay Colony granted land to settlers west of the Connecticut River. These new land barons followed Indian paths and began building communities. Royal Governor Sir Francis Bernard named the area in honor of his home in England. He also named a town after himself and one for his friend Prime Minister William Pitt.

It is written that the first skirmish of the Revolution took place in Great Barrington in 1774, when the townsfolk, tired of the king's relentless taxing, armed themselves and overthrew the English judges at the town hall.

The beauty of the Berkshires began to draw writers and artists who found inspiration among the mountains and sparse populace. Soon, however, the wealthy also found the area as an escape from their daily routines. The Gilded Age had arrived, and the rich built "cottages" as summer homes. These cottages were actually stately mansions. At one point, there were ninety-three such getaways in the Berkshires.

The stock market crash of 1929 took its toll on these estates, and they were either sold for whatever they could get or were given away as dowries. Many became resorts, restaurants and museums, while others fell into ruin.

Today, the Berkshires still exude the magic that brought settlers there. It is no wonder that so many have never left, even though they are long gone from the mortal world.

THE MOUNT
The Eternal Home of Edith Wharton

Famous author Edith Wharton bought 113 acres in Lenox, Massachusetts, and in 1901–02 designed and built what she called her "first real home," now known as the Mount. The stunning landscape and even more impressive mansion are truly sights to see. Sadly, she spent only six years there. After moving, in 1911, to France, where she would remain, she sold the Mount in 1912. In 1913, she divorced Edward Wharton. Edith never returned to her first real house, at least not in life. She died after suffering a stroke on August 11, 1937, at Pavillon Colombe. She was seventy-five years old. Edith Wharton was buried at Cimetière des Gonards, Versailles, yet her spirit still haunts the Mount to this day. She is not alone, for the reported ghosts of her former husband and her close friend and writer Henry James also make occasional appearances, as do a host of other former tenants.

Edith Newbold Jones was born on January 24, 1862, in New York. Many believe that the saying "keeping up with the Joneses" was a direct reference to her family. Summers were spent in Newport when not traveling the world. She married Edward Wharton on April 29, 1885. Her first poems were published in *Scribner's* magazine in 1889, and history was made from there.

Stun if by Land

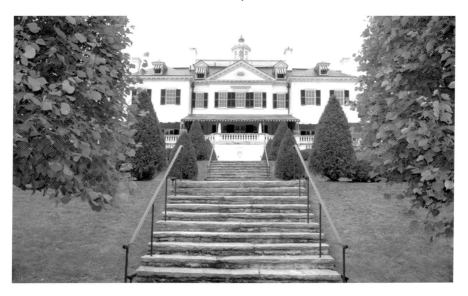

The Mount in Lenox is home to several ghosts that once tenanted there.

The accounts of her ghost at the lavish manor are endless and as illustrious as her life. The Mount was at one time a boarding school called Fox Hollow and later home to an acting troupe called Shakespeare and Company. The troupe, though long since vacated from the mansion, still resides close by in Lenox. Many of the residents living in the house witnessed such phenomena as typewriters clicking away at all hours; a man who appears in the Henry James Room, where the writer often stayed; the sounds of girls giggling and running through the halls; and Edith's wandering spirit, often seen in various parts of the house. There is a room upstairs called the Fox Hollow Room in honor of the boarding school. Witnesses have claimed to hear children playing and laughing in that area, as well as outside on the great lawn.

A now famous account of Wharton's ghost is told in various writings. Andrea Haring was resting in Edith Wharton's old room when she woke to a freezing chill. The room had a different décor than when she had crossed the threshold a short time before. There was antique furniture where there had been empty space. She suddenly saw three figures in the far corner of the room. One was seated at a desk, writing, while another, the spirit of Wharton, was reclined on a settee. The third she recognized as Edward Wharton standing in the corner. They were completely animated in movement yet cast not a shred of sound forth. As she rose to leave the room, the three halted in their tasks and stared straight at her. Shaken by their presence, she gave a nod to them that was reciprocated by

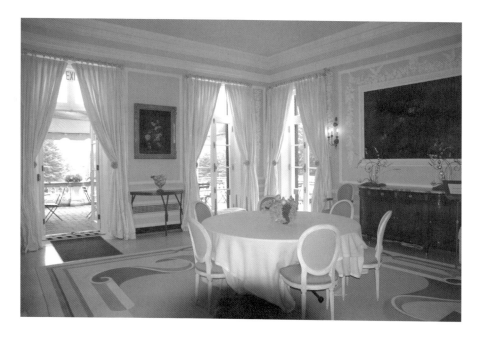

The dining room at the Mount, where an angry spirit chastised a theatre group for making too much noise.

the trio. She gathered a few friends and went back to the room, but the furniture and ghosts were gone and the room was once again warm. Wharton's ghost has also been seen roaming up and down the halls or entering rooms.

One night, the troupe was giving a performance on the patio off the dining room when a man in early twentieth-century clothing appeared out of nowhere, chastising them for making such a racket. He then moved toward the dining room doors and vanished before the astounded performers' eyes.

The stables are reported to be haunted by an unknown entity as well. The presence is felt in the upstairs area. Footsteps follow visitors around in the sizeable edifice. Many of the spirits that wander the grounds are unknown, but they seem to eternally bask in the splendor of the great mansion. The Mount offers tours and even holds social events. You never know with whom you might end up hobnobbing.

Take Exit 2, Route 20, toward Lee and then turn left onto Plunkett Street. The Mount will be on your left.

THE EASTOVER

In 1910, Harris Fahnestock, a New York stockbroker, built the Eastover on fifteen hundred acres of land as a summer cottage for him and his family. The buildings consisted of a brick Georgian mansion, a stable, an eight-car garage, a chauffeur's home and a pump house. Sixty-five servants tended to the family of five from June to October. In 1946, George Bisacca purchased the property and founded the Eastover Resort. For over sixty years, the family-owned resort has been a place where people come to get away and relax at an affordable yet entertaining retreat. The Eastover boasts one of the largest privately owned Civil War museums in the United States. It also has buffalo on the property and offers horseback riding, among other activities. But is it haunted?

There are many who say yes, but it is not a malevolent haunt. Guests and staff have had brushes with the paranormal on occasion. Some have seen shadows move about in the old stables, now called Tally-Ho. They have heard voices in the stables and felt a presence near the stage. Maybe the ghost was once a performer or liked entertainment. One staff member, Ryan, has seen shadows pass by him when he is alone in the building. One night he heard footsteps coming from the floor above. He made sure that the building was empty and then set up a recorder. He managed to capture the phantom footsteps on tape. There is nothing harmful about the place; in fact, it is a beautifully peaceful retreat.

The mansion's third floor seems to be inhabited by some friendly ghosts as well. One group caught what looks like a woman in the dorm room, while others have captured what looks like transparent forms in the upper floors of the mansion. Guests claim to have witnessed the ghost of a little boy on the upper floor. There are also those who have heard voices when there was no one else in the area. The three largest buildings seem to hold remnants of the past, but in a positive way, for there are many guests who return to the resort over and over. Perhaps that is why the ghosts have never left.

Is the Eastover haunted? Find out for yourself and stay a weekend.

The Eastover is located at 430 East Street in Lenox. Call 1-800-822-2386 or visit www.eastover.com. Take a right off Route 20 onto Housatonic Street. Turn left onto East Avenue and follow to main driveway of Eastover.

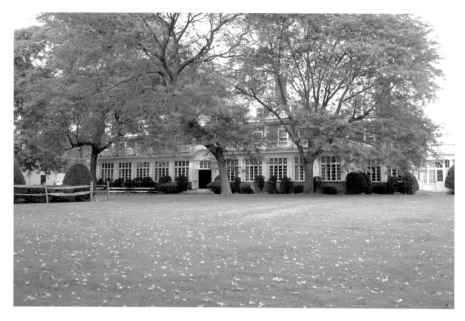

Eastover Resort is home to a vast Civil War museum and a few other remnants of the past.

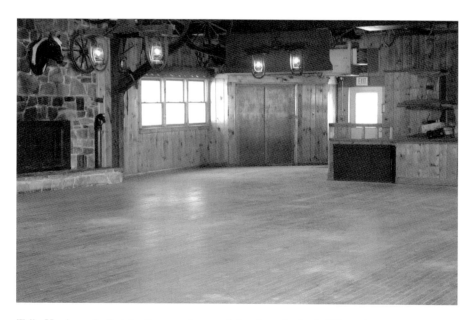

Tally-Ho dance hall at the Eastover is one of the places in the building where a presence is felt and heard.

Whistler's Inn
Charming and Haunted

Innkeeper Lisa Mears is not afraid to talk about her permanent residents at Whistler's Inn. In fact, she is quite proud of her ghosts, as can be read in the following letter:

> *We are always having new occurrences at the inn. A lot of our guests feel timid and are afraid to mention anything about their experiences at The Whistler's Inn for fear people will think they are crazy, but once we show the film that The Travel Channel did on us,* Where Spirits Speak, *which is shown around the world several times a year, they open up and tell their stories. We are called The Love Inn by several of our guests because most of the stories have to do with falling in love, love affairs, marriage, divorce, etc. Also, my father is the author of several fiction novels (Richardchasemears. com), and one of the books,* Anubis Rex, *includes mystery scenes at the Whistler's Inn (called Hidden House) in the book. My father, Richard Chase Mears, is Author In Residence at The Whistler's Inn.*
> *Best regards, Lisa at The Whistler's Inn*

The inn is home to at least two, if not three, ghosts. Ross Whistler, nephew of the famous painter James Abbott McNeil Whistler, lived in the 1820 English Tudor mansion until his death in 1927. His widow hired a woman by the name of Nancy Hedwall to assist her with the household duties. Nancy seemed a bit overwhelmed by the amount of work and companionship required at the mansion, so Mrs. Whistler let Nancy bring along her sister, Helma, and Helma's husband, Paul Anthony, to act as cook and chauffeur.

It was not long before Nancy began to have eyes for Paul. Over the next several months, they would steal away to a remote corner and exchange their passion. Sometimes it was in the attic, and other times, in the garage, where Paul spent much of his day anyway. One night, Helma walked into the garage and caught the couple in an embrace. Helma never spoke to her sister after that. Paul died in an auto accident shortly after and was buried across from the Whistler home.

Soon, Helma died, followed by Nancy, and although they never spoke, Mrs. Whistler buried them both with Paul. Since then, their ghosts have been seen wandering about the inn. There are fifteen guest rooms at the inn, but rooms 1, 5, 7 and 12 seem to hold the most activity. Other strange occurrences include windows coming out of their frames and water pipes

mysteriously bursting when the Mearses are not at the inn. Owner Richard Mears and his wife, Joan, seem to think that the ghosts do not like being left alone for any period of time. The inn is open to guests who would like to experience a bit of the Berkshires' past, along with some of its people.

Whistler's Inn (413-637-0975) is located at 5 Greenwood Avenue in Lenox. Take Exit 2/Lee from Route 90 to Route 7. Stay north on Route 7A into Lenox. Whistler's Inn is at the corner of Route 7A and Greenwood Avenue.

TANGLEWOOD
The Sounds of Music and More

In 1849, William Tappan and his wife, Caroline, purchased 210 acres of land with a little red farmhouse as its focal point for use as a retreat from the hot and sweltering environment of Boston in the summer. Tappan soon rented the estate next door, called Highland, overlooking Lake Makeenac. Famous architect Richard Upjohn had designed the grand manor, which immediately swept Caroline off her feet. They offered a small cottage to a close friend so that the struggling novelist could finish his latest work undisturbed. The book was to be called *The House of the Seven Gables*.

Tanglewood in Lenox is home to soul-stirring music and perhaps a few stirring souls.

Young Nathaniel Hawthorne had just lost his job at the Salem Customs House, so he, along with his wife, Sophia, and their children, jumped at the opportunity to reside in the Berkshires for a spell. They tenured there from March 1850 to November 21, 1851. Hawthorne also wrote a few other short stories during their time there, and one in particular, "Tanglewood Tales," is where the land derived its name.

Caroline later built her dream mansion, while William remained in the cozy little farmhouse next door. The farmhouse burned in 1890 but was replaced by a replica in 1947. Concerts began on the property as early as 1934, but in the winter of 1936, the Tappan family gave the 210-acre parcel of land to the Boston Symphony Orchestra. On August 5, 1937, the largest crowd to date filled Tanglewood to hear the orchestra play an all-Beethoven concert. Today, it remains the summer home of the orchestra, whose melodic sounds echo over the mountains. In 1987, the orchestra acquired Highwood to be used as office space and rehearsal areas. It did not, however, expect to have an extra, unseen guest lodging with it.

No one knows the identity of the music-loving phantom, but there is no doubt that Tanglewood has a ghost. Unseen hands stroke musicians' hair, and doors open and close as if someone is entering or leaving the room. Faucets also turn on and off by themselves. Many people have tried to find the elusive spirit—even *Star Wars* composer John Williams has investigated Tanglewood in hopes of finding the ghost that dwells at the famous landmark.

Leonard Bernstein once jumped from a window seat, throwing his hands in the air and shouting at the unseen guest. Some claim that it might be the spirit of thirty-seven-year-old Oreb Andrews, who died in 1822 when a tree fell on him. There was once a memorial plaque that stood in his honor but was disturbed during renovations. Whoever the ghost is, it just adds to the enchantment that makes the Berkshires so wonderful.

Follow directions to Whistler's Inn, but take a left onto Walker Street. Bear left onto Route 183 at the statue in Lenox and continue to Tanglewood.

For the More Adventurous
Becket Land Trust Historic Quarry and Forest

Rusty trucks and digging machines sit derelict within the forlorn borders of Becket Quarry. These relics once rumbled with life in the prosperous quarry

but now sit silent and haunting in the place where they were abandoned so many years ago. They are not alone, for also within the quarters of the excavation site reside the revenant spirits of those who once toiled at the great granite ledges that tower over the landscape.

The Chester-Hudson Granite Company was established in the 1860s and soon became a prosperous venture. Even the flood of 1927, which forever wiped out most of the local businesses, such as charcoal, lumber and raw silk, did not scathe in any way the quarry's operations. But in the 1960s, workers left the dig and never returned, at least not in physical form.

On August 27, 2005, the Becket Land Trust Historic Quarry and Forest was opened year round to the public as a self-guided tour, with lots of walking trails, artifacts, exhibits and, yes, ghosts. Visitors traversing the trails and old roads of the site have witnessed apparitions moving among the rusty machinery, as if they are still busy with the daily toils of yesteryear. Some have felt an unseen presence brush by them while touring the quarry.

Since the historic site opened, countless visitors have ambled among the crumbling cliffs of granite, where trees have taken a stronghold on the ledges and the spirits still return to finish their day's work.

To get to the site, take Exit 2, Route 20, off Route 90. At the intersection of Routes 20, 8 and Bonnie Rig Hill Road, take Bonnie Rig Hill Road. Continue to Quarry Road. The parking area is on the right.

MOUNT GREYLOCK
Western Gateway to the Mohawk Trail

The Mohawk trail is sixty-three miles long, stretching from Millers Falls west to New York State. The trail remains one of the oldest designated scenic routes in the country. Its scenic vistas are unmatched, especially during foliage season, when the trail boasts some of the best views for leaf peepers in the world.

The Mohawk Trail started out as a travel and trade footpath for the Indians. It was one of the most heavily traveled paths due to its proximity to abundant streams and woodland that afforded camping, fishing and hunting. The Mohawk Trail is named after the Mohawk tribe, which was at odds with the Pocumtuck tribe over fishing rights at Salmon Falls in Shelburne Falls. The English and Dutch colonies drew up a treaty for the two tribes, but when a member of the Mohawk tribe was killed, the Mohawks attacked and annihilated the Pocumtucks. Popular belief is that

Mount Greylock, to the right, is the gateway to the Berkshires from the north and eternal home of "Old Coot."

the treaty was a setup so that the European settlers could get the two tribes out of the way for their own purposes. There is a plaque commemorating the treaty at Salmon Falls.

Many famous notables have traveled the trail, and some still haunt their favorite places along the famous route. From King Philip to General Burgoyne and Mark Twain, the trail is still alive in spirit.

BELLOWS PIPE TRAIL
The Home of "Old Coot"

In 1861, a North Adams farmer named William Saunders left his home to fight for the Union in the Civil War. About a year later, his wife, Belle, received a letter that he had been seriously wounded in battle. She never heard anything more. Fearing that he had passed, she hired a local man to help tend to the farm. She eventually married the man, and he adopted her children.

In 1865, the war ended and the soldiers headed home. Among them was a bearded, ragged farmer named William Saunders who had survived his injuries. He walked to the farm in hopes of reuniting with his wife but instead saw her in the arms of another man, whom his children now called "daddy."

This devastated the poor Saunders, who turned and headed toward Mount Greylock, where he built a crude cabin in the remote portion of Bellows Pipe. There he lived out the rest of his days, occasionally working at local farms for his necessities. The locals called him "Old Coot," as he never gave them a proper name. No one recognized him due to his injuries, which aged him beyond his years. It is told that he

even helped at his own farm, sometimes joining his family for meals. Many say that he was insane, either from the war or from losing his family. Either way, one cold winter day, hunters stumbled upon his shack, where they found Old Coot dead. They were more than frightened when his spirit jumped from his body and scampered up the mountainside. To this day, his ghost is seen on Mount Greylock, always ascending the peak but never reversing direction. Bellows Pipe derives its name from the wind that whistles through the pines, sending an ethereal din through the mountains. Maybe it is not the wind.

Mount Greylock, originally called Saddleback Mountain, is located in North Adams. Take Route 7 North to Lanesborough. At the brown Mount Greylock sign, take a right onto North Main Street. Follow for one and a half miles to the Visitor's Center. There is an auto road that is open seasonally from late May to November 1. It is eight miles to the summit from the Visitor's Center via the auto road.

The Mohawk Trail is a scenic byway stretching across northwestern Massachusetts into New York. Its views in autumn provide the finest foliage sights in America.

HOUGHTON MANSION
Home of Berkshire Paranormal

On August 1, 1914, Albert C. Houghton, former first mayor of North Adams, his daughter, Mary, a friend by the name of Sybil Hutton and chauffeur John Widders decided to take a drive to Bennington, Vermont, in their new seven-passenger Pierce Arrow. Widders had been recently taught to drive the horseless carriage. At about 9:30 a.m., they were in Pownal, Vermont, heading up what is now Oak Hill Road, when they came across a team of horses stopped on the side of the road. As Widders attempted to steer around the team at about twelve miles per hour, the delicate road gave way, and the car tumbled down the mountainside, rolling over three times before coming to rest in an upright position in a field. Everyone except Mary Houghton was thrown out of the car. Sybil Hutton died immediately when the car rolled onto her. Mary was badly injured and was placed in a passing auto, but she died five hours later at the hospital.

Although he was exonerated for any wrongdoing by investigators, John Widders could not forgive himself for the tragedy. At 4:00 a.m. on August 2, Widders ambled into the cellar of the Houghton barn and shot himself

Houghton Mansion in North Adams is the home of Berkshire Paranormal and is haunted by several intelligent spirits.

in the head. Mr. Houghton never recovered from the accident and died on August 11, 1914. He left the 1895 mansion to his other daughters, who then sold it to the Freemasons. The Houghtons are all buried in the family plot at the cemetery a few miles down the road on Route 8. John Widders is buried just to the right of them.

The mansion is home to Berkshire Paranormal and has several ghosts that roam its vast rooms and halls. Mary's room is one of several in the mansion that harbor ghostly activity. The chair next to the left fireplace seems to hold a lot of energy. Mary's spirit is also active in the room, as members of Berkshire Paranormal, who are also Freemasons, have found out. The mansion has become a regular stop for paranormal groups. Arlene and I have been there several times and have experienced some of the most compelling occurrences of the paranormal there.

The ghost of John Widders is also reported to reside in the mansion. Josh Mantello of Berkshire Paranormal took a stunning photo in what is labeled "Widder's Room." The figure is easy to spot looking out the window of the room. Witnesses have also heard a voice say "Goodnight" on countless occasions. They believe the voice is John Widders bidding them a safe evening. Events and activities at the 72 Church Street estate

are so numerous that they have been on various television shows. The mansion offers ghost tours and hosts investigations, conferences and other related paranormal gatherings. To tour the mansion or find out about the events, call 413-692-7989.

The Haunted Hoosac Tunnel
Look but Dare not Enter

The Hoosac Tunnel is located below the Mohawk Trail in northwest Massachusetts. *Hoosac* is an Indian term meaning "people of the long house."

After the War of 1812, it became evident that trade to the west needed to be sped up a bit. The mountains proved too rigorous for the sluggish oxcarts that hauled goods to New York via the Mohawk Trail. The idea was first proposed in 1819, but many years and deaths kept the $21 million project on a slow track. The digging commenced in 1851, and work was slow until a boring machine was introduced. On March 16, 1853, the machine made a ten-foot cut into the rock before breaking down. Now it was back to manual labor.

Nicknamed the "Bloody Pit," the tunnel claimed 193 lives. Strange incidents plagued the project. Shortly after nitroglycerine was introduced, the Hoosac Tunnel explosive experts were the first in America to try it. On March 20, 1865, Ned Brinkman, Ringo Kelley and Billy Nash were responsible for setting up some charges in the rock. Brinkman and Nash set the charges, and Kelley was the one to ignite them. Unfortunately, he set off the charge too soon, and the other two men were buried alive by tons of falling rock. On March 30, 1866, Kelley's body was found at the site where Brinkman and Nash were killed.

On October 17, 1867, thirteen men were killed when a candle ignited some naphtha fumes that had leaked from a gasometer lamp. The hoist caught fire and collapsed into the shaft. For almost a year, the men remained in their watery grave, until a new pump house was built and they could be removed for proper burial. During that time, workers swore they saw misty figures carrying picks and shovels wandering about the opening of the shaft hole. They would vanish and leave no footprints in the snow-covered mountaintop.

In 1868, tunnel workers complained to Mr. Dunn about the eerie moaning of a man in agony deep in the tunnel. They would not enter the hole after dark. Mr. Dunn and another man, Paul Travers, decided to investigate. The following is a famous excerpt from Travers's report:

Dunn and I entered the tunnel at exactly 9:00 p.m. We traveled about two miles into the shaft and then we stopped to listen. As we stood there in the cold silence, we both heard what truly sounded like a man groaning out in pain. As you know, I have heard this same sound many times during the war. Yet, when we turned up the wicks on our lamps, there were no other human beings in the shaft except Mr. Dunn and myself. I'll admit I haven't been this frightened since Shiloh. Mr. Dunn agreed that it wasn't the wind we heard…I wonder?

On October 16, 1874, Frank Webster, a local hunter, vanished without a trace. He was found stumbling around the tunnel three days later, incoherently ranting about being attacked by ghosts inside the tunnel.

On November 27, 1873, the west portal was opened, and trains soon chugged through the 4.75-mile burrow. There are many more who have seen the ghosts of the tunnel since its opening so long ago. Berkshire Paranormal tells the story of the "Lantern Man," seen by those who dare enter the dark crypt, which was at one time an engineering feat but is now among the most haunted places in the world.

Follow the trail to Whitcomb Road. Take a right onto Whitcomb Road and proceed very cautiously as the road is dangerously steep. Bear left at the end of the road. The tunnel entrance is several yards up on the left.

THE CHARLEMONT INN
A Night with Dignitaries of the Past

The Charlemont Inn ranks as one of the most haunted places in Massachusetts. Owners Charlotte Dewey and Linda Shimandle have entertained guests they can and cannot see for several years. The Charlemont Inn has welcomed its guests for dinner and lodging since 1787. Mark Twain, Benedict Arnold, General John Burgoyne and President Calvin Coolidge rank among the many notables who have slumbered within its chambers. The years have come and gone, but not all of the past beings have left the historic building.

One of the ghosts of the inn is the spirit of a young girl named Elizabeth. She seems to favor Room 23 as her favorite haunt. The staff has concluded that it may have once been her room, so they have put a

Charlemont Inn along the Mohawk Trail has the ghost of Elizabeth and perhaps a few historical figures lingering as well.

small bed in the room to appease her. Guests and staff alike have heard footsteps in the halls that resemble a woman in heeled shoes. Elizabeth likes to stomp up and down the halls when the inn is full. Maybe she is upset that she does not have her privacy. Creaking on the stairs has caused many curious guests to look over the railing, only to see the steps empty of the living. Elizabeth's ghost is also blamed for moving items in the room, as well as rustling the bed linens. My wife and I have stayed at the Charlemont on several occasions and have come out with some strange occurrences and an EVP (Electronic Voice Phenomena) from Room 23.

Elizabeth is not the only specter at the inn. Other guests have seen the spirit of a Revolutionary War soldier and what some think is a former innkeeper. Perhaps it is Ephriam Brown, the man who built the Charlemont. He has been spied in the upstairs quarters of the inn. Elizabeth may have been related to Ephriam, but there is no record to date that identifies for certain whether the two are connected.

The downstairs parlor is the scene of an interesting occurrence. There was a mirror that once hung on the wall near a place where some investigators photographed three vortexes. The mirror was mysteriously removed from the wall and laid across the room with the glass in tiny fragments, yet all of

the fragments were in place on the floor. No one heard a crash or the sound of breaking glass.

If it is good food, entertainment and ghosts that you crave, the Charlemont is your best bet.

The Charlemont Inn (413-339-5796) is located on Route 2/Mohawk Trail in Charlemont. The inn is in the center of the village.

HISTORIC DEERFIELD
History that Still Lives

A trip to the Mohawk Trail is not complete without a stop, or even a stay, in Deerfield. This little village/museum is ripe with the tales and legends of American history. Main Street is lined with colonial-era houses, where visitors can while away the hours learning about early American life and perhaps even seeing some.

Deerfield was first settled in 1673 and became incorporated in 1677. It was then call Pocumtuck. According to the *History of Deerfield, Massachusetts* by George Sheldon, John Pynchon signed a treaty and deed to the land with a Pocumtuck sachem named Chaque, or Chauk, who may or may not have had absolute authority to sign over the land and much less idea that he was actually doing so. The settlers drove the Pocumtuck tribe out of the area, forcing them to take refuge among the French. On September 18, 1675, a small band of Indians attacked and defeated a group of militia headed by Captain Thomas Lathrop. In retaliation, Captain William Turner and his men attacked a tribal meeting ground at what is now Montague on May 16, 1676, killing two hundred Indians, mostly women and children. The warriors returned to the camp, but it was too late.

In the early hours of dawn on February 29, 1704, 300 Abenaki and Kanien 'kenaka (Mohawk) warriors, led by some 50 French military officers, raided the little hamlet of Deerfield. Approximately 48 villagers were brutally slaughtered, buildings were burned and 111 survivors were forced to march three hundred miles north into Canada.

The Reverend John Williams and his wife were asleep when the Indians rushed into their room. Williams grabbed a pistol, but it misfired, actually saving his life. He and his neighbors watched as the buildings were burned and the "Maquas" killed many of the townspeople. The villagers were forced to march three weeks north into Canada. Many perished along the way,

and those who survived were taunted for their religious beliefs while being shuttled from one settlement to another. It took a few years for Governor John Winthrop to gain the English captives their freedom. On November 21, 1706, fifty-seven captives, including two of Williams's children, arrived in Boston. In his book, *The Redeemed Captive Returning to Zion* (published in 1707), Williams depicts the horrors of those who were dispatched mercilessly for lagging behind or becoming a burden due to illness and hunger. John Williams later married his wife's cousin, Abigail Allen, and had five more children. He died on June 11, 1729, at the age of sixty-five.

The preacher's first wife, Eunice, was not so fortunate. Having just given birth, she was very weak when she fell while crossing the Deerfield River. An Indian dispatched her with a single blow of his tomahawk. A bridge now sits over the river at the spot where she died. There is a plaque that tells of the terrible ordeal. Her shadow is frequently seen standing near the bank of the river, looking out at the road. She is also witnessed standing on the covered span that crosses the banks of her demise. Passing motorists sometimes stop to help a woman and get the scare of their lives when the figure vanishes in front of them. A man fishing once saw a woman standing near the opposite bank of the river as he walked by the bridge to cast his line into the water. He then noticed that she was gone, and in the next instant, she was right next to him. He beheld something very eerie about the woman. She was almost transparent. Before he could make haste from the scene, she vanished before his eyes.

The covered bridge mysteriously burned in 1969 but was rebuilt in 1972 into the ninety-five-foot-long, thirteen-and-a-half-foot Howe truss overpass that extends over the site where Eunice Williams's spirit is to forever roam looking for redemption for her untimely death.

As for the Williams family, their daughter Eunice, who was taken in the raid when she was seven, remained with the Indians. She married a Mohawk named Aronson and changed her name to Kanenstehawi. She died in 1786 at the age of ninety and was buried in Indian habit. Some of her belongings are on exhibit in the Deerfield Museum. A book, *The Unredeemed Captive*, written by John Demos and published by Alfred A. Knopf, Inc. (1994), is the story of her life and the family's struggle to get her back.

Another spot that is haunted is the Old Deerfield Burying Ground. During the raid, two of Williams's children were killed in the house, along with one of his female servants. The pregnant woman was hacked to death with a tomahawk and then scalped. Her presence is seen and heard every leap year near where she was buried. The monument to the massacre sits at the far corner of the graveyard.

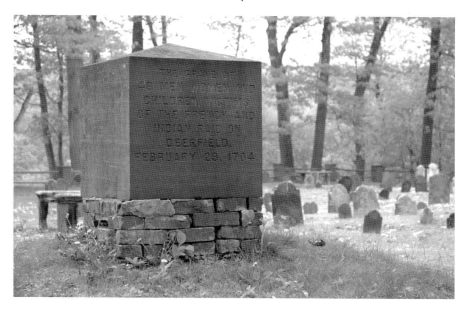

The grave of the forty-eight men, women and children killed in the raid on Deerfield on February 29, 1704.

Some swear that the echoes of that fateful morning reverberate through the midnight air. Could it be the wind or restless spirits looking for justice?

One notable grave in the cemetery is that of a woman who died during childbirth. Sadly, the infant died as well. On the woman's stone is a carving of her, with the child in her arms, lying in a half-opened coffin. The image is a bit macabre but also very heartrending. The graves of John and Eunice are located under a tree near the center of the burying yard. Eunice's stone reads, "She fell by the rage of ye barbarous enemy."

The Hinsdale-Anna Williams House is another site of a reputed ghost. Visitors to the museum have seen a woman dressed in colonial clothing float through the halls and rooms. Upon investigation, they find the rooms empty.

DEERFIELD INN
In the Heart of Deerfield Haunts

While you are visiting the past, why not spend a night at the Deerfield Inn? It is historic, scenic, charming and, of course, haunted. J.M. Bradley

The Deerfield Inn, where guests are treated like royalty, even by the spirits.

and his brother opened the inn in 1884 after their hotel in the center of the village burned. George Arms, a local builder, helped expand the inn to the size of a hotel in 1885. It was the finest lodging in the area. Guests arrived by every means possible, including trolley, which dropped them off right at the front door. In the 1920s, a double room with running water could be secured for three dollars a night. If only that were the case now!

Current innkeepers Jane Howard and Karl Sabo keep the inn looking like it did when it first opened. A blend of bygone eras and modern amenities makes for an unforgettable stay. Perhaps this is why the ghosts of the inn linger as well.

The spirits are presumably those of John and Cora Carlisle, who owned the inn just before John's death in 1932. Cora began holding séances in Room 148 in an effort to contact her deceased husband. She may have succeeded, for that room is now the center of all spirit activity. Voices are heard coming from the room when it is empty, and all of the doors will not stay closed at once within the room. In 1979, a strange force roused a couple from their sleep in Room 148. They awoke to find smoke brewing in the room from an unattended fireplace. The smoke was quickly doused, but the couple could not explain what woke them.

Some think that the spirit of Eloise Southard, former housekeeper of the hotel for many years, is responsible for the haunting of the Deerfield Inn. Her spirit seems to clean and tidy items in the rooms.

To visit the Deerfield Inn, call 1-800-926-3865 or go to www.deerfieldinn.com.

Historic Deerfield is located in northwestern Massachusetts. Take Interstate 91 to Exit 25, Route 5 North, to Historic Deerfield. The Visitor's Center is across from the museum store, where all information on the homes and tours is available.

OTHER THINGS ALONG THE WAY

Train Rides from Lenox to Stockbridge

Two round trips leave daily from June to October from the Historic Lenox Station. Call 413-637-2210 or visit www.berkshirescenicrailroad.org for more information.

Stun if by Land

Herman Melville's Arrowhead
780 Holmes Street
Pittsfield, MA 01204
4413-442-1793
www.mobydick.org
*The famous author lived here from 1850 to 1863, when he wrote *Moby Dick* and several other novels. It is now owned and operated by the Berkshire County Historical Society.

Hail to the Sunrise Statue

The statue that depicts an Indian hailing the sunrise is located in Charlemont on Route 2/Mohawk Trail. It is a monument to the five Indian nations of the Mohawk Trail.

Shelburne Falls

This beautiful hamlet is located just west of Route 91 on the Mohawk Trail. There are some wonderful attractions such as the glacial potholes, trolley museum and the world-famous Bridge of Flowers. There are also lots of shops and cafés where one can while away the hours in the quaint little town. Contact the Shelburne Falls Village Information Center at 413-625-2544.

Kenneth Dubuque State Forest.

The remnants of the old town of South Hawley, incorporated in 1792, are within the forest. Visitors can see a rare beehive charcoal kiln, an old factory complex and many cellar holes that were once homes and businesses to the residents of the town, which was abandoned by the 1950s. The roads are unpaved but are accessible to vehicles.

Take Route 8A south off Route 2 for eight miles to the SCA/Hallockville Pond entrance.

STAYING IN THE BERKSHIRES

The Inn at Stockbridge
Route 7, 30 East Street, Box 618

Stockbridge, MA 01262
1-888-466-7865
www.stockbridgeinn.com
*Sixteen luxuriously appointed rooms that fit the themes of the Berkshires. Among the features are full candlelit breakfasts, a pantry open for coffee, tea, hot chocolate and snacks, complimentary wine and cheese every evening and twelve acres of land.

Red Lion Inn
30 Main Street
Stockbridge, MA 01262
413-298-5545
www.redlioninn.com
*A 1773 tavern that burned in 1896 but reopened in 1897. It is filled with original antiques that were collected from colonial times after the townspeople saved them from the fire. There are plenty of rooms and eight guesthouses around the inn. It is also reported to be haunted.

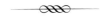

THE QUABBIN, MASSACHUSETTS
Reservoir of Wraiths and Relations

The Quabbin Reservoir is thirty-nine square miles containing 412 billion gallons of water, making it one of the largest man-made reservoirs in the world. It was created in 1938 to serve as a water supply for the eastern part of the state. It now serves many western towns as well.

The Quabbin is named after an American Indian chief, King Quabbin, who lived in the valley centuries ago. The name *Quabbin* means "many waters." Europeans settled the area about 1730, naming it Swift River Valley. In the 1930s, the Massachusetts Metropolitan Commission built two dams in the southern sector of the valley, thus flooding the four towns, and renamed it Quabbin. Before the dams could be built, homes, businesses and

A look at the Quabbin Reservoir from the shore, where four towns were swallowed up.

other buildings had to be leveled. Topsoil was scraped off and trees felled. Railroad tracks were taken up, and thirty-six miles of state highway were redirected. Eight train stations had to be demolished, and the inventory left in the mills, stores and homes was auctioned off. The buildings were mercilessly bulldozed, and the people were forced to sell—many at much lower prices than their property was worth.

After the towns were flooded, the hills in the center became islands, with remnants of the past as their monuments. The lost villages and towns of the Quabbin are: Dana, North Dana, Prescott, North Prescott, Greenwich, Greenwich Village, Millington, Bobbinville, Enfield, Smith's Village and Doubleday. Today, only Dana Common remains totally above water. The common and its several foundations are easily accessible from Route 32A. There are many strange tales of the Quabbin that make it worth reading about and even more fun to visit.

The Visitor's Center (413-323-7221) is located at 485 Ware Road (Route 9) in Belchertown. The entrance is marked "Quabbin Reservoir/ Windsor Dam." An ancestor of Joshua Spooner actually works there. Later in this chapter you'll find the story of Joshua Spooner and the famous well. There are books about the Quabbin for sale at the center, along with historical posters and pictures.

Legends Set in Stone

The grave of Warren Gibbs is part of the mystique of the region. In early spring 1860, Warren Gibbs became very ill. Neighbors brought cider for him to drink that made him feel somewhat better. His wife then prepared a meal of oysters for the recovering man. Very shortly after this meal, the burning and thirst returned. Warren Gibbs grew increasingly ill until he died a few days later.

Warren's brother, William, suspected that his wife had mixed arsenic in the oyster stew before serving it to Warren. The authorities did not have enough evidence to warrant an autopsy and dismissed the claim, but William was so convinced that the wife did away with his brother that he decided to put it on the dead man's marker. The stone reads:

Warren Gibbs
Died by Arsenic Poison
March 23, 1860
Age 36 years 5 mos 23 days
Think my friends when this you see
How my wife has dealt by me
She in some oysters did prepare
Some poison for my lot and share
Then of the same I did partake
And nature yielded to its fate
Before she my wife became
Mary Felton was her name.
Erected by his brother
Wm Gibbs

Mary's family became very upset at the accusation and pulled the stone from the plot. William put the stone back and threatened them with legal action if they were to touch it again. He also put a curse on the stone to give his warning more impetus. The stone stood untouched for many years but was replaced when people began to vandalize it. The Pelham Historical Society Museum has the original. However, there are claims that the headstone in the museum is not original. There are tales of the stone disappearing, only to be mysteriously returned due to the impending curse. In one case, a Professor Valentine of Springfield College purchased a farm in Palmer. During renovations, he uncovered a gravestone in the dirt floor in the cellar. He immediately called the authorities, and they recognized the

stone as Gibbs's. The stone had vanished in 1940; Valentine found it in 1947. Since then, it has rested peacefully—but does Warren Gibbs?

Warren Gibbs is buried at the Knights Cemetery in Pelham. Take Route 9 to Route 202 North. Follow this to Gate 8, which is also Packardville Road. Take a left onto Packardville Road across from Gate 8. The cemetery is one-tenth of a mile on your left. The Gibbs stone is the stone at the far right corner, next to the front wall of the cemetery.

Quabbin Park Cemetery

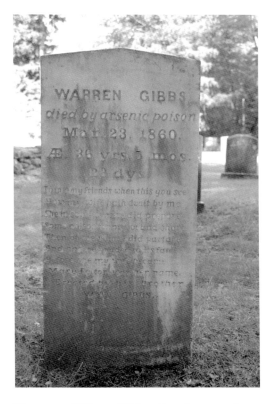

The stone of Warren Gibbs telling the story of how, according to his brother, he met his demise.

When the undertaking of the Quabbin was to begin, the gruesome task of removing 7,561 bodies from the four towns became top priority. Some had been buried for a long time. The relocations started in 1928. The Metropolitan District Water Supply Commission estimated the cost of eighteen dollars per body to be moved to the Quabbin Park Cemetery. For families who wished to bury their loved ones elsewhere, the commission granted thirty-five dollars for reinterment. Approximately 6,551 graves were relocated to Quabbin Park; 1,010 were buried at other cemeteries.

The process of moving the bodies was carefully logged and executed. Each lot was photographed, and families brought forth their deeds, which enabled them to secure a plot in the new cemetery. The original stones were transferred and set on sturdy foundations. The graves were carefully dug up, and every piece in the grave was sifted out of the plot and mixed with soil from the site before the box was sealed. There were about five hundred unmarked graves that were also relocated to the new cemetery.

The Civil War statue that once graced the green of Enfield now greets visitors to the Quabbin Park Cemetery.

As you enter the cemetery, there is a small bordered site on the left. This is a time capsule that will be opened one hundred years after the building of the Quabbin. In front of you is a statue of a Civil War soldier. This statue originally sat in front of the Enfield church. The night before the town was to be razed, the citizens burned the church. The two cannons on either side of the monument were from Enfield and Dana Common. Other monuments of interest flank these artifacts.

One of the vanished towns, Greenwich, was actually called Quabbin before being renamed in 1754 for the Duke of Greenwich. There was a one-hundred-room hotel and a nine-hole golf course called Dugmar Country Club. The walls of the clubhouse still lace the landscape of Curtis Island in the reservoir.

All ghost towns have heroes, and the Quabbin is no exception. Amiel Whipple of Greenwich was known as an unsung hero of the Civil War. Having reached the rank of brigadier general, Whipple joined the front line near the White House in Washington to personally oversee the fieldworks in repelling Rebel forces. He was mortally wounded by a sharpshooter and died on May 7, 1863. The achievements of his military career were quite astounding, and he was given a full military funeral in Georgetown, Maryland.

Rufus Powers of Prescott is said to have invented the first known smoke alarm in 1866. It was U.S. Patent #54202. It did not quite catch on at the time, even though it worked way better than anyone would have imagined.

SPOONER WELL
A Revolutionary Tale

From Quabbin Park Cemetery, head east to Brookfield. Here lies the site of the Joshua Spooner well, which is reportedly haunted. Sometime before 1778, Bathsheba Spooner plotted to do away with her husband, whom she claimed was an abusive drunk. One day, in 1777, Bathsheba spied a Continental soldier ambling by her door. He was very weary from his walk after fighting under the command of General George Washington in New Jersey. Bathsheba took the boy, sixteen-year-old Ezra Ross, into her home to nurse him back to health. They soon fell in love.

Ezra soon left to visit his home in Linbrook while the war was still raging. Many British soldiers were displaced and looking for lodging. William Brooks and James Buchanan showed up at the Spooner House, and Bathsheba took to entertaining them. She wrote to Ezra for his speedy return, as she now had a plan to get rid of her husband once and for all. Upon Ezra's return in February 1778, Bathsheba became pregnant. Whether it was Ezra's baby has never been figured out.

Ezra, Brooks and Buchanan were hesitant to help Bathsheba in her plot until she promised them money.

The site of the Spooner Well in East Brookfield. The granite stairs and foundation of the home are under brush.

On March 1, 1778, Brooks hid behind the front gate while the others waited in the front room. Joshua Spooner soon returned from his habitual visit to Cooley's Tavern. As Joshua climbed the four large granite steps to his house, Brooks jumped from behind the gate and attacked him. It is said that Joshua Spooner first yelped in terror, "What is the matter!?" Moments later, the cry of "Murder!" rang through the midnight air. Brooks had beaten and strangled poor Joshua Spooner. The other two men came out and helped throw him in the well headfirst.

Mrs. Spooner paid her cohorts, and they were off. She then absentmindedly ordered two servants to fetch water from the well. The three soldiers were arrested the following day in Worcester and incriminated Bathsheba as the main conspirator. As Mr. Spooner's body was being removed from the well, Bathsheba had but three words: "Poor little man."

Within a few months of the crime, all four were sentenced to hang. The trial, which took place on April 24, 1778, lasted from eight o'clock in the morning until midnight. Bathsheba, who was pregnant, asked for a stay of execution until her baby was born. Midwives, who were at odds as to whether she was really pregnant, examined her. The state, having no conclusive evidence that she might really be pregnant, went ahead and hanged her on schedule. She was the first woman to be hanged in the new American Republic. Joshua Spooner was laid to rest at the cemetery on Route 9, just past the Brookfield Common. His stone bears the abridged story of his demise and the fate of the conspirators who sent him to an early grave.

The well is still visible in East Main Street in Brookfield. From Route 9, take Route 148 North for about a half mile. At the fork, bear right onto East Main Street. Just after you enter East Main Street, look for a small stone monument on the left. That marks the spot of the Spooner well. The granite steps are there, but brush has concealed them, as well as the foundation to the home, from view. The monument sits across from a private residence. The well, just behind the obelisk, is capped for safety, and there is a lot of poison ivy around it.

Enter the main cemetery gate and walk to the right for several yards. You will see a small limestone marker that reads: "Joshua Spooner, Murdered March 1, 1778 by three soldiers of the Revolution, Ross, Brooks, and Buchanan at the instigation of his wife Bathsheba. They were all executed at Worcester, July 2, 1778."

DANA COMMON AND THE
TOMB OF ASA "POPCORN" SNOW

The next stop is of great interest. It is the site of Dana Common and the original tomb of Asa "Popcorn" Snow. Gate 40 on Route 32A is marked with a sign set back from the road a bit. From the entrance gate, it is about a mile and three quarters to Dana Common.

A short distance down the path there is a foundation on the right. This is the remains of a barn that once belonged to the poor farm. The destitute of Dana worked the fields and held their own at this place of early welfare. On the right, the road forks slightly where the original lane once was. The thoroughfare was replaced by the present one due to the dangerous curves that proved too hazardous as the population of the town grew. The road reunites at the common. All that remains are the foundations of the buildings and some walls. The granite posts of the cemetery still stand in the field to the right of the common. The empty lot is grassy, but you can imagine how it must have looked, with the posts marking the boundaries where the more than seven hundred stones once rose up from the terrain.

The wall, known as the Vaughn Wall, still stands prominently on the outer side of the common along a road that now leads into the woods. This meticulously laid-out wall of small stones was a retaining wall to the Vaughn family home. There is a chunk missing from the wall where a former resident, Earl Cooley, once took the corner a bit too fast in his automobile while entering the common and clipped the partition. The Johnson home once graced the common with soft music from a harp as Mrs. Johnson delighted the locals with her musical abilities before treating them to milk and cookies.

A few feet away from her house was the blacksmith, Moses Marcille. In 1899, Marcille and his family moved from Dana after their home burned down. They returned in 1904 and moved into a home next to the Congregational church. On March 21, 1907, Moses finished his dinner with his wife and two children and then set out to his blacksmith shop, where he grabbed his gun and some bullets. He returned to the house and promptly started arguing with his wife. He raised his gun and shot her in the shoulder and right lung before finishing himself off. Blanche Marcille scurried to the Stevens' store to summon help. Mrs. Marcille soon recovered from her wounds and lived to a ripe old age.

There is a stone with a bolt protruding from the top of it. Inscribed on the stone is "O Marcille 1899." This is where the original Marcille home was before it burned in 1899. It is located a few hundred feet east of the common.

At the far end of the common sits the ruins of the Eagle Hotel. The hotel was a stately edifice, with a grand front porch set under white columns. Now, all travelers see is the grassy cellar, which nature has reclaimed. Just across from the hotel was the home of Grace Dunn. The cellar still has a strongbox in it that was too heavy and costly to remove. Next to the hotel sits the remains of the local store, then the Johnson House and finally the Vaughn House. The entrance to the common is where the old town hall once sat. There is a cement walkway that used to be for the building but now leads to nowhere. Next to that is the foundation of the school and behind it, the remains of the old cemetery.

A monument erected by those who lived there marks the common, and there have been reunions by the surviving citizens ever since the common was reopened to the public.

Once back at the gate, bear into the woods beside the portable toilet to the tomb of Asa "Popcorn" Snow. His story is a strange but true tale from the annals of the Quabbin.

Asa Snow was born on Cape Cod in the 1790s. In 1840, he moved to Dana. His farm was located where Gate 40 on Route 32A now sits. Asa Snow was a vegetarian whose diet, according to narratives, consisted mostly of popcorn and milk. His first wife, Isabelle, committed suicide in 1844 by hanging herself from a piece of her dress in the barn. Asa buried her at the family plot on the property. His daughter died a year later, and he buried her next to Isabelle.

In the late 1860s, Asa decided to build a family vault, where he had his wife and daughter placed. Before he reinterred his first wife, he displayed her remains for anyone who might be interested in seeing them. His second wife did not care for that idea. Perhaps that is why she was buried somewhere other than the family vault.

As Asa got older, he began to build a metal coffin with a glass top. At this period in time, most coffins were made of wood, and a glass top was unheard of. Snow also arranged for the local undertaker to spend seven days watching the coffin, in case Asa suddenly woke up.

Asa died on November 29, 1872, while dragging a pig carcass into his house for guests to feed on. As per agreement, the undertaker looked in on

Snow, but for only three days. It is reported that Snow's second wife, Eunice, relieved him of his duties, feeling that if Asa did not wake up after three days, surely the cold would have gotten to him.

The unusual tomb attracted the inquisitive from all parts. Many people came to look at the well-preserved body of Popcorn Snow through the glass window in the coffin. A news report from 1912 tells of how Snow's body looked the same as it had when he died forty years earlier. His hair was the same shade, and his clothes showed no signs of tatter or age. Resting on top of his coffin was an old box containing the remains of his first wife and daughter. There is a legend that someone once stole the teeth from Isabella's skull and used them to decorate a timepiece.

It was written in the local papers that Snow's ghost would leave his tomb on November 15 of each year and travel to the former site of his wife's grave. The glowing apparition could be seen floating among the ruins of the old homestead before returning to his mausoleum until the next fall brought another awakening from his eternal repose. Residents of the area shied away from his farm on that particular night.

There is also a story of two men from Boston who made a bet with each other that one of them would spend a night in the tomb. The brave skeptic tied his horse outside the tomb and entered it for a night of debunking. Not long after he began his vigil, his horse went into fits outside and broke free from its hitch, running terrified into the woods. The would-be cynic made haste from the crypt in fear. Although he was paid for the bet, he never came within miles of the area again.

Not long after, someone broke the glass of the coffin, causing Asa Snow to wither rapidly. Local authorities sealed the tomb from other legend trippers, and it remained that way until 1944, when the Metropolitan Water Commission relocated the bodies and leveled the farm. Newspapers still relate that Snow comes back each year to look over his old farm.

Take Route 32A to Gate 40. Just before you enter the gates, you will see the remains of Asa Snow's home. After you enter the road past the gate, there is an outhouse. A trail just past the outhouse heads toward a field. Across from that field are the remains of the tomb where Snow was interred. If you decide to venture out to Dana, do it when the leaves are down and the flies are gone. If the stories are true, November 15 might be a good time.

Where to Stay

Inn at Clamber Hill
111 North Main Street
Petersham, MA 01366
1-888-374-0007
www.clamberhill.com
*Located just minutes from the Quabbin, this 1920s estate sits on thirty-three acres of woodland that turns into a leaf peeper's paradise in the autumn. There are five uniquely decorated rooms that will cater to any taste. There are no televisions, but plenty of books and a CD player are available in every room.

PART II
BOO IF BY SEA

MYSTIC SEAPORT, CONNECTICUT
A Ghost for Every Occasion

Mystic, Connecticut, is truly a magical place, hence the name. Actually, the name is derived from the Mohegan/Montauk/Narragansett term *missi-tuk*, or *missi-tuck*, which means "large river driven into waves by wind or tide." Robert Burrows and George Denison, the first English settlers to the area, arrived about 1654. Denison settled on the east side of the river, while Burrows found his home on the west side. It was not until 1665, after an influx of such noted families as Williams, Gallup, Mason (all on the east side), Fish and Packer (both on the west side), that the General Session in Hartford decided on the name "Mistick" for the colony. The Pequots, of course, had already given the area that name. Today, it is known as Old Mystic.

Mystic is a historic parcel of land that lies within the towns of Groton and Stonington. It has no recognized formal governing body, yet it holds its own as a place of wonder and imagination. The 2000 census recorded 4,001 people residing in the village separated by the Mystic Bridge. Some of the destinations in this chapter lie within the perimeter of the aforementioned towns, just outside Mystic's outskirts.

The town is filled with antique shops, eclectic wares and a broad variety of restaurants. It is home to Mystic Pizza, where scenes from the famous 1988 movie of the same name were filmed; Mystic Aquarium; and Mystic Seaport, the largest maritime museum in the world where the last wooden

whaling ship in existence, the *Charles Morgan*, lays anchor. Steven Spielberg used Mystic Seaport in some of the scenes for the 1997 movie *Amistad*. The Hardy Boys book #47, *The Whale Tattoo* (1968), takes the reader into Mystic Seaport, where Frank Hardy is almost done in by a villain while aboard the *Charles Morgan*. Mystic Seaport also happens to be where the mystery is solved.

But it did not take two sleuthing teens to bring the ghosts of Mystic to life. Many who have long since turned to dust in the physical sense still hold tenancy in one of the most interesting tourist spots in the East. Staying at a haunted bed-and-breakfast in Mystic is easier than one might think. Restaurants, and even tourist attractions, have more to offer than meets the eye.

VISITING THE GHOSTS

Our first destination is the ever-famous Mystic Seaport Museum of America and the Sea. There are several ghosts that seem to have made harbor here. No one knows who the spirits really are, but they do like to make an appearance from time to time.

Mystic Seaport is the largest museum of maritime history in the world. Three Mystic residents—industrialist Edward E. Bradley, Dr. Charles K. Stillman and attorney Carl C. Cutler—founded the Marine Historical Association on December 29, 1929. It was officially renamed Mystic Seaport in 1978. Not only does it consist of a whole village along the edge of the Mystic River, but it also boasts a few ships of bygone eras, including the *Charles Morgan*. Guests can see how rope was made, how coopers and blacksmiths toiled at their trades and how old-time stores really fashioned their interiors with the wares of the day. There is also a tavern and some homes for public visitation. For the more adventurous, there are ships to wander through. A walk-through reveals how sailors and fishermen really lived aboard these vessels. Some men would endure such conditions for up to five years. It is no wonder that a few may still be wandering the decks of the *Charles Morgan*.

Jethro and Zachariah Hillman, out of New Bedford, Massachusetts, built the pride of Mystic Seaport between 1840 and 1841. It was launched on July 21, 1841. It was named after a prominent whaling ship mogul living in New Bedford at the time. The all-wooden whaling ship spans 113 feet in length by 17½ feet in depth. Its main mast towers 110 feet above the main deck. It

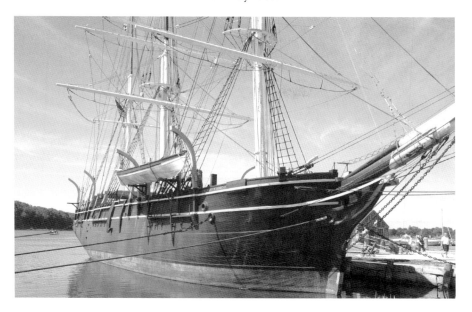

The pride of Mystic Seaport, the *Charles Morgan*, is reported by some to still have a crew onboard.

can be rigged for 13,000 square feet of sail. This beautiful remnant of a lost trade would set out to capture whales for their oil in the days when America relied on such a commodity for machinery lubrication and to light the dark nights. The *Morgan* had the capacity to hold ninety thousand gallons of oil. Its heyday was from 1841 to 1886, before it was sent to the West Coast in 1887. In 1906, the *Morgan* returned home to New Bedford and was retired in 1921 after thirty-seven voyages under twenty different captains.

Kerosene lamps were introduced in Germany in 1854 and soon found their way to the United States. Still, many of the common folk could not procure such luxuries and relied on whale oil for their source of light. By the twentieth century, whaling had become an all but obsolete trade that legend and folklore would immortalize in poetry and prose. The *Morgan* was acquired by the museum in 1941 and became a National Historic Landmark in 1966. The ghosts must have enjoyed the publicity.

Crews of thirty-five spent up to five years at a time at sea in hopes of filling their ship with the precious oil. Perils aboard a whaling ship were numerous and often deadly. Many a brave whaler went down in the line of duty. Perhaps it is one of these lost souls that still linger among the ropes below deck. The misty phantom fisherman has been reported smoking

a pipe while relaxing among the cord. Ethereal voices also permeate the area of the foc's'tle (forecastle to us landlubbers), where the crew slumbered after a hard day's work. Staff members have checked out the area, thinking perhaps a stray sightseer had remained onboard after closing, only to find that they were the only ones on the ship—at least, the only physical beings aboard the vessel. There are a couple of staff members who will not venture onto the boat alone. They attest to having heard the voices and have even been touched by an unseen entity while below deck. A few have heard the steady thump of what might be someone walking below deck. When they went to investigate, the sounds trailed off. Ships, of course, will creak with the rolling of the tide, but the *Morgan* is in low, calm water. Whether you see a ghost, the *Charles Morgan* is a thrill to board and tour.

Once you have shed your sea legs for dry dock, head over to the country variety store, where there is a chance of greeting shoppers from the other side. Dayne, one of the more distinguished staff members at the museum, experienced what appeared to be an intense paranormal occurrence. Dayne related his encounter:

> *I was at the register with a box of items when I suddenly saw a woman with three children walking down one of the aisles. I never heard them come in. The door is heavy and makes plenty of noise when opened. They were dressed in modern attire, so I never gave it a second thought. I turned quickly to place some items from the box onto a countertop, then promptly turned toward the family to see if they needed help, but the place was suddenly empty. They were there, then gone. The strangest thing about the incident is that the heavy wooden doors slam when opened and closed, yet I never heard the woman and children come or go. The building is small, and there is no way they could have entered or left without being noticed, but they did. I was bewildered all day while contemplating what I had just witnessed.*

The variety store is not the only place where you can purchase a gift and rub elbows with a revenant from the past. The museum shop at the entrance of the seaport was once a private home. A woman recently came into the store and told the staff that her grandmother was born in that building. The museum purchased the building and renovated it into the shop seen today by visitors. The center staircase, upstairs rooms and outer shell remain mostly as they were a century ago. Whoever still resides within the store is not happy with a few shelves toward the rear near the staircase.

The variety store in Mystic Seaport where staff member Dayne had an unusual experience.

Many of the staff members and customers have witnessed the glassware on those rear shelves suddenly take on wings and fly into the middle of the store. In some cases, it appeared as if an invisible arm was swiping a row of merchandise off the shelf at once. Dayne and Alyssa are among the staff members who have witnessed the phantom vandal. "You can actually see the items fall from the shelf in succession, one after another," Alyssa said. Other phenomena include sudden cold spots and the feeling of being watched while in that area.

Perhaps the ghosts are angry that their former living room is now cluttered. Conceivably, there may have been a rocking chair there, or a desk, where leisure time meant a lot to whoever is causing the mess. No one is certain what it is, but there is something going on in that corner. Arlene and I tried a few EVPs, but it was a bit noisy that day as customers were mulling around, some quite interested in our search for the spirit's identity. Arlene is a professional dowser. No one knows how the rods work, but they do. Water company trucks carry dowsing rods and teach each employee how to use them. You do not need to be sensitive or psychic. The rods work using the person holding them as an agent of their bidding. Arlene's inquiries, along with those of a few other interested onlookers, returned some positive answers, but she could not get a name. It could be that the mischievous spirit wants to remain anonymous.

There may be other ghosts in the buildings that lie within the museum. The Spouter Tavern is known for some strange occurrences that have yet to be explained—footsteps heard upstairs or in the taproom when it is supposed

to be empty and lights working on their own. A busy seaport turned museum can hold many reasons for these occurrences, either from this side of the veil or the other.

Who are the ghosts of Mystic Seaport? Again, no one knows. That is just a small part of the alluring charm that the seaport museum possesses. It is a magnificent historical place where one can spend a lot of time—some have spent an eternity!

Take Exit 90 off Route 95 and follow signs for Mystic Seaport.

More Spirits to Shop With

Another locality of lofty phantom interest is the Emporium at 15 Water Street. The store is an incredible eclectic mix of gifts and galleries. Cindy, who manages the store, has been there for nineteen years. She likes to refer to the merchandise as "off color." Cindy has also lived on the fourth floor above the store for seventeen years. Originally, the building served as a post office during the Civil War. Many letters and notices of soldiers coming home sent a rush of relief through family members. Unfortunately, bad news also arrived at the edifice of those who gave their lives for the cause. One can only imagine the sadness or grief that has imprinted itself into the walls. Perhaps that is why there are a few spirits lingering long after their time on earth has ended. Maybe they are, as Cindy suggests, family members still waiting for news of their loved ones. No one is sure, but there seems to be energy that remains alive and well in the Emporium.

One spirit is that of a boy of about twelve. He predominantly likes to play tricks on the girls who work there. The basement is where the children's toys and eclectic gifts are sold. It seems a fitting place for a child to eternally frolic among the vast wonderland of amusement. Becky, the assistant manager, has had her share of incidents but has since told the ethereal residents that she would rather be left alone. "I just shout, 'Don't freak me out today!' and they don't bother me," she said. One co-worker constantly feels the presence around her. The staff members are not the only people who experience the ghosts of the Emporium—customers have been touched or have seen the little boy ghost as well.

Cindy's apartment is also a center of activity. No clock will work when placed in her kitchen, and there is a presence felt just outside the room. She has also heard footsteps walking from the kitchen into the living room. Her

The Emporium in Mystic is interesting, eclectic and haunted.

The toy section of the Emporium, where the ghost of a child is seen playing.

son was raised in the building. He is no stranger to the energy that roams the premises. Every so often, they both feel a disconcerting force at one door that leads from the apartment to the gallery. They move very quickly when having to walk by that particular spot. "You can feel it, and it is kind of an agitated energy. It makes us pass by that area very quickly or avoid it altogether," Cindy said. If she goes away for the weekend, items seem to take on wings and fly off shelves. It is as if the spirits have separation anxiety and do not want her to leave them alone. Once, when she was going through a less than pleasant time, something touched her hand as if to tell her that everything was going to be all right. "The energy here is not evil or anything like that. It just lives in the building," Cindy said. Spirits want to feel comfortable in the

place where they linger, so it is unlikely that they will be malevolent. Would you want to live somewhere that you didn't like?

Robert Bankel and Evan Nickles are the owners of the Emporium. They related a story to me and Arlene about the previous owner. A man named Paul had bought the place, and he started painting and fixing it up. One day, he painted himself into a corner and called to one of his helpers to open a window and bring a ladder so he could exit from there. He turned around quickly to see if anyone was within earshot. When he turned back, the freshly painted floor had a mysterious set of footsteps running across it.

The Emporium is a stop that would be worthy of your time even if it were not haunted. But its resident spirits just make it more enticing to visit!

Once in Mystic, follow Route 27 past Mystic Seaport to the statue in the square. Take a right at the statue and continue over the bridge. Take a left onto Water Street just across from Mystic Pizza. The Emporium (860-536-3891) is on your left at 15 Water Street.

Food and "Spirits"

While you are on Water Street, you might want to check out Captain Daniel Packer Inne. The inn is home to fine food and drink, as well as, as expected, spirits. The inn was built in 1756 after former square-rigger Captain Daniel Packer purchased the property. From the 1750s until the late twentieth century, the hostel remained in the Packer and Keeler (their descendants) families.

The inn was one of the many rest stops between New York and Boston. Guests were treated to first-rate food and drink, followed by adventurous tales of the brine by the captain himself. When the sun's rays welcomed a new day, he would transport the coach, horses and travelers across the Mystic River by rope ferry. He would then send them merrily on their way and wait for the next group to arrive.

In 1979, Richard and Lulu Kiley restored the inn to its original splendor using construction techniques that were customary in the eighteenth century. The pub is reminiscent of those quaint little seaside taverns that conjure images of old salts playing cards and drinking hearty ale. The family still owns the inn and maintains that original charm throughout. Maybe that is why the Captain Packers Inne has a few permanent patrons.

Judy Hartley runs the inn and loves her ghosts. There are several of them to witness, depending on where you dine. An old woman is seen in the attic, as is a sea captain. The captain could be Daniel Packer, but no one has been able

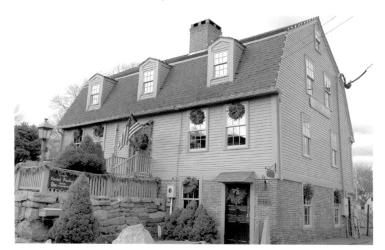

The Captain Daniel Packer Inne has a few revenants of the past still roaming within its walls.

to get an answer out of the salty spirit. There is also the ghost of a little girl in the building. Reportedly, a girl named Aida was born there on New Years and died of scarlet fever in the house. Her voice has been heard, and the soft footsteps around the public house are attributed to her ethereal ramblings.

Many of the forty employees have heard footsteps and voices on the stairs long after the restaurant has been emptied and secured. Some have seen the apparitions in the attic dining room. The identity of the ghosts remains a mystery, but that does not mean they will not make an appearance when they feel like it.

The Captain Daniel Packer Inne (860-536-3555) is at 32 Water Street, just down the street from the Emporium on the left.

SLEEPING WITH THE ENERGY

There are many haunted bed-and-breakfast places in Mystic or just outside the village's border. They seem to make up most of the ghostly community. Maybe they liked the accommodations too much to move on, or the building was once their home in another era. Either way, visitors to the magical Mystic tour get a chance to spend the night with a sometimes unseen guest.

The House of 1833 is an elegant Victorian mansion turned bed-and-breakfast. Owners Robert Bankel and Evan Nickles have spared no expense in creating a romantic atmosphere that is sure to bring you back in time. The

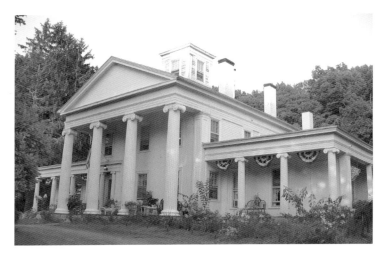

The elegant House of 1833 in Mystic has been quiet for the new owners, for now.

five guest rooms are lavishly decorated, and two feature a hot tub and sauna. One, the Cupola Room, sits on top of the house, providing a stunning view of the surrounding area.

Elias Brown built the home in 1833. He was a prosperous attorney who married Elizabeth Burrows. Her family owned granite quarries in Rhode Island. The Browns had twelve children, so it would appear that a large house was in order. Brown was responsible for the first bank in Mystic. In fact, that bank sits in the Mystic Seaport Museum of America and the Sea, just across the little street from where the *Charles Morgan* is docked. The home was a guesthouse in the late nineteenth and early twentieth centuries, called the White House. In 1946, Roy Smith turned it into an exquisite dress shop. It stayed that way until it was purchased for use as a private residence in the 1970s. Matt and Carol Nolan bought the estate and turned it into a bed-and-breakfast in 1994.

Evan Nickles and his partner, Robert Bankel, who is actually of Brown family lineage, are in their fourth year at the bed-and-breakfast. They have kept the elegant Victorian charm that originally radiated from the manor. The home features two formal parlors. The front parlor boasts a Belgian marble fireplace, and the second parlor embraces visitors with a fireplace highlighting a black marble mantel with fine detailing, as well as a nineteenth-century crystal chandelier to gallantly light the evening. The latter was reserved as a music room, with a baby grand piano and pump organ. These spectacular rooms are furnished in the period style for all to enjoy. Potted palms and ferns, as well as orchids from the owners' private collection, create

a natural eternal spring interior. With the robust color of fresh-cut blooms, one discovers a beautiful rhythm in the mansion's woodwork and period moldings. As for the ghosts, there are historical reports, but Robert and Evan have yet to meet them.

"The previous owners experienced a number of things, but it has been pretty quiet for us so far," Robert said. He recited the history and haunts of the house without missing a beat. He even told us some ghost stories concerning his family. One dates back to the Civil War, when his great-great-grandmother put a lot of money into a ship. The night the ship sank, a blaze of fire formed in the center of the parlor, where she had been entertaining some friends. It mysteriously appeared and then died down, leaving no burn marks or traces of fire whatsoever. There was no explanation for it until much later, when news came of the ship catching fire and sinking at the exact moment the phantom fire reared up in the parlor. Inquire about this story when staying at the manor and you will be quite absorbed by Robert's tales of the past.

As for the haunted precedent of the House of 1833, the Nolans, who owned the inn from 1994 to 2005, were certainly not without company. A woman in a long gown was often seen standing in the doorway of the music room just off the front parlor. Guests and staff alike had witnessed this specter as she seemingly watched over the room. Perhaps it was Mrs. Brown making sure that her sophisticated styling was still intact. She is completely harmless and perhaps may even be nothing more than a residual haunt. Residual haunts are not really ghosts per say. The earth, being magnetic, tapes a moment in time, and when conditions are right, that moment is replayed. This is also called the stone tape theory, in which it is said that stones, rocks and sand, containing iron, along with quartz and other minerals, can store data and replay it over and over.

Our visit to the House of 1833 was quite memorable. Robert's antique cars graced the immaculately landscaped front lawn. We felt like we were on the set of a movie or had been transported back to the Gilded Age of the rich and famous. Arlene and I brought a fellow investigator, Kevin Fay, along for the trip. The innkeepers were exceptionally nice and even offered us their signature chocolate chip cookies—"The stuff dreams are made of," according to the proprietors. Although I did not try any, I have no doubt that they are extraordinary, as is everything else in the house.

Much to our dismay, the specter in period clothing did not materialize to greet us. We did not capture any EVPs or any strange anomalies on camera, but the antiques and fireside stories were more than worth the visit. Staying a night at the mansion is an experience in itself.

To get to the House of 1833 (1-800-FOR-1833), take Exit 90 off Route 95 and head away from Mystic Seaport. (From the north take a left off the exit; from the south, take a right.) At the Old Mystic General Store, veer to the right. The House of 1833 is on the right at 72 North Stonington Road, a little over a mile from the exit.

MORE ANTIQUES AND GHOSTS

A few scant miles up the road from House of 1833 is a place called Antiques and Accommodations. Tom and Ann Gray are the charming innkeepers who own the carefully restored Victorian home. The home is decorated with formal antique furniture and accessories. If you are in awe of their décor, many of the pieces are offered for sale, which is why they chose the appellation Antiques and Accommodations. Each morning, the Grays serve a multicourse candlelight breakfast on fine china with polished silverware. They offer soothing sherry in the rooms and fresh flowers by your bed. Their establishment is on the National Register of Historic Places and has been written up in every major magazine and newspaper in the region. One look at the hostel and you will want to move in forever, just as one spirit seems to have done.

Arlene and I talked to Tom about his otherworldly guest, and he was not at all afraid to revel in the accounts. The occurrences are by no means malicious; the spirit seems to be a former tenant who loved the place dearly in life. That is why most spirits remain in old houses. The circa 1820 house features two beautiful rooms, each decorated in period furniture and very comfortable beds.

One of the more common occurrences is the smell of cigarette smoke that seems to permeate the front parlor at about 2:00 to 3:00 a.m. No one can explain the odor, as the inn is a good distance from neighbors' homes and the Grays do not smoke. It has been proven that the sense of smell is the only one of the five senses that cannot be deceived. If someone smells something, they can rest assured that it is there. Guests report odd noises, but in old houses, these are quite common. Maybe they should have attempted to investigate the source more closely, or perhaps they were content to believe that something paranormal may have gone bump in the night.

Tom related an incident concerning the attic of the house. There are four unfinished rooms there that were once occupied. Tom had been working up there for a while before leaving to go to church. He left the light on and went to the evening service. He left the church at about 9:30 p.m. and walked home. As he approached the bed-and-breakfast, he saw a woman in a long

black Victorian dress slowly pass by the attic window. There was only one guest staying on the first floor at the time, and Tom did not have to guess that she would not have been dressed in period attire wandering around the attic. Another thing Tom noted was that the window was right next to a wall. In order for the woman to pass by the panes, she would have had to walk through the wall—an improbable feat for the living, but not for a spirit.

This prompted the Grays to have someone check out the house. The investigator confirmed the presence of a woman in the attic, but he also felt the presence of two children there. A stay at the bed-and-breakfast is a must for its surrounding area and nineteenth-century charm. Who knows who or what you might meet?

Antiques and Accommodations (1-800-554-7829) is located at 32 Main Street in North Stonington. Visit the website at www.antiquesandaccommodations.com. Take Route 95 North from Mystic to Exit 92. Turn left onto Route 2 West and continue 0.4 miles to a traffic rotary. Take the second exit onto Route 2 West for 1.2 miles, and then veer slightly to the right after the Green Onion restaurant. The house is 0.2 miles on the right.

MORE SPIRITS FOR THE NIGHT
The Old Mystic Inn

Books have a way of suspending time within the binding of their pages, telling wondrous tales of legend and imagination. New England is fortunate to have reared some of the greatest authors history has known. Many have paid homage to these distinguished purveyors of prose and poetry, and the Old Mystic Inn gives accolade to New England's legendary scribes. After all, the Old Mystic Inn was once a bookstore with over twenty thousand tomes shelved within its frame.

The house, presumably built by John Denison, dates back to 1784, after he purchased the lot from Samuel Williams the year before. In 1785, Denison sold the house, along with the Hatter's shop on the property, to his son Nathan. Nathan, in turn, sold the property to his brother-in-law, John Baldwin. When Nicholas and Lucretia Williams purchased the land in 1799, it had already seen several owners move on. When Nicholas passed, Lucretia inherited the homestead and drew up a rather peculiar will that was executed upon her death. Ten people received a five-foot, eleven-inch by

The charming Old Mystic Inn is frequented by the ghost of a woman who supposedly lived across the street.

five-foot, two-inch portion of the house, and six other inheritors were given a whopping three-foot, three-inch square section from ground to roof.

As we fast forward to the twentieth century, a Mr. Copp owned the house during the Roaring Twenties, renting the lower floor. In the 1930s, Mr. and Mrs. Frank and Mr. and Mrs. Kenneth Williams occupied the building. The Williams family were proprietors of the store across the street from 1875 to 1967. In 1959, Charles Vincent bought the estate and turned the home into a bookstore called the Old Mystic Book Shop. He sold his towering tufts of tomes until 1986. According to the history of the Old Mystic Inn, Mr. Vincent knew where every one of his twenty thousand volumes could be found within his shop.

The home's new life as a bed-and-breakfast began on June 25, 1987. In 1988, the Carriage House was added to accommodate the growing influx of visitors to the quaint and quiet historical town. Since then, lodging at the Old Mystic Inn has reigned supreme. In honor of Mr. Vincent's love of literature, the sign for the inn has his likeness carved into it. As a tribute to the great literary figures whose tomes once graced the walls, each of the eight guest rooms is named after a New England author. In fact, a famous work from the namesake author rests on a table in the room for occupants to peruse.

Such a magical place would somehow be incomplete without the occasional spirit visitation to enrich the atmosphere and stir the imagination. Perchance, the shadow of an author might pop by to see how his or her writings fare after so much time has passed, or you might meet the ghost that has actually been visiting the inn for several decades. Two friends of present innkeeper Michael Cardillo Jr. have seen the spirit of someone

The hallway area of the Old Mystic Inn is a center of paranormal activity.

standing in the kitchen. Michael sometimes hears someone walking around upstairs in the Melville room when he knows it is otherwise vacant. A guest was once brushing her hair in front of a mirror in the Hawthorne Room when she suddenly saw a reflection of a woman standing behind her. On another occasion, the latch on the door began to move up and down. The woman went to the door and opened it, but no one was there.

Michael once heard footsteps in the upstairs hallway and concluded that it was his lone guest staying in the Dickinson Room. No sooner had he eased his mind with that notion when his solitary tenant entered the front door.

The Old Mystic Inn is a favorite haunt of a very nice lady dressed in a white gown. It is reported that she used to visit the inn quite frequently in the 1960s, until her house burned down. The inn was someplace special to her and apparently still is.

Michael does not feel threatened by the specter, and none of the guests has ever had a problem with the wandering woman in white. For all purposes, the Old Mystic Inn is a warm and relaxing place where history and imagination meet somewhere in another time.

The Old Mystic Inn (860-572-9422) is located at 52 Main Street in Mystic. E-mail omysticinn@aol.com. Take Exit 90 off Route 95 and head away from Mystic Seaport. (From the north, take a left off the exit; from the south, take a right.) The inn is located across the street at the fork where the Old Mystic General Store and Post Office stands.

WHITEHALL MANSION
Comfortable Stay, Confirmed Haunted

Various paranormal groups have investigated this 1771 structure and have confirmed that it is quite haunted. Dr. Dudley Woodbridge, a medical doctor, theologian and minister, built the manor. Whitehall Mansion has five guest rooms with a continental breakfast and wine and cheese reception. It also has some ghosts to keep you company. There are reports of children laughing, as well as floating clouds of mist. Lucy, Dr. Woodbridge's daughter, is the foremost ghost of the hostel. The building was restored by the Stonington Historical Society and later sold for use as an inn. It is the perfect base location for visiting all destinations in Mystic. The spirits are an added bonus.

Whitehall Mansion is located at 42 Whitehall Avenue in Mystic. Call 860-572-7280 for more information.

Minister Dudley's daughter, Lucy, is reported to be one of the ghosts at Whitehall Mansion.

OTHER PLACES TO STAY IN MYSTIC
Maybe Haunted, Maybe Not: Let the Adventure Begin

Adams House
382 Cow Hill Road
Mystic, CT 06355
860-572-9551
www.adamshouseofmystic.com

Brigadoon Bed and Breakfast
180 Cow Hill Rd
Mystic, CT 06355
860-536-3033
www.brigadoonofmystic.com
*A traditional Scottish bed-and-breakfast in a 250-year-old restored Victorian home.

Harbour Inne & Cottage
15 Edgemont Street
Mystic, CT 06355
860-5572-9253
www.harbourinne-cottage.com

The Steamboat Inn
73 Steamboat Wharf
Mystic, CT 06355
860-536-8300
www.steamboatinnmystic.com

The Whaler's Inn
20 East Main Street
Mystic, CT 06355
800-243-2588
sales@whalersinnmystic.com.
*Great views of Mystic Bridge and waterfront.

NEWPORT, RHODE ISLAND
More Ghosts than Anywhere Else in New England?

We all know Newport Rhode Island as the summer playground for the elite of our society. Yachts harbor at fine dining places on the water while shoppers spend their wealth freely. It is a menagerie of who's who as one passes through the streets of this lavish town. But it was not always that way. Rhode Island's original capital city was once known as the scourge of the colonies, where scoundrels, rogues and pirates walked the streets without fear.

No wonder there are many restless spirits that still hold quarter in this city by the sea. Some of them are the nefarious remnants of the days when pirates and rumrunners were given free roam of the village. Others are spirits of those who loved their wealth so much that they still refuse to part with it. Some are from faraway places, brought to the town one way or another to spend eternity haunting those who enter their domain. Ghostly mansions, haunted taverns, mysterious landmarks and a ghost ship or two—Newport has it all, awaiting your arrival.

There are many places to stay in Newport, from inexpensive motels to lavish, over-the-top, five-star hotels. For the sake of this book, however, I shall endeavor to give you a few of the haunted locales. Where you choose to stay from there will be your own judgment.

THE BLACK DUCK

Arlene and I stayed at the Black Duck Inn at 27 Pelham Street during our visit, as we are more of the bed-and-breakfast type. The house was originally built in 1898 as a duplex and was later converted to an inn. It was in total disrepair when Mary Rolondo purchased it in 1994. Her flair for charm and quaint hospitality is evident in the décor.

The inn got its name from a rumrunning vessel during Prohibition. The vessel smuggled rum into Newport Harbor for the thirsty, yet wealthy, citizens

of the town. The ship's illicit voyages to Newport irked the Coast Guard so much that it opened fire on the boat one foggy night, killing three out of the four crewmen onboard. This action prompted a rebellion in the streets of Newport, where no coast guardsman was safe. The incident gained national attention, and even Washington was forced to deal with the attack on the *Black Duck*. The surviving crewmember was acquitted and released.

The *Black Duck* may be landlocked, but it still harbors some unknown haunts. The unseen occupants play with the lights and turn on the radios in the rooms. Mary related to me how all of the alarm clocks went off in the guest rooms at the same time, even in the ones that had not been occupied the night before.

Guests have heard ghostly voices in the rooms next to them when they are certain they are empty. Upon checking, they find they are quite alone in the area. Mary has heard the voices as well. She was tidying up the rooms just before Christmas when the ethereal articulations arose out of the void. "I was cleaning the room and was all alone," she recalled. "I heard this low mumbling voice beside me. I froze for a second, wondering if I actually was hearing what I thought I was. It then rose to an audible level, then faded away quickly." Mary did not understand what the voice was saying but was sure that someone was with her that day. Another common occurrence is phantom footsteps in the otherwise empty rooms upstairs. The eerie walking happens at all hours of the day and night. Mary knows it is not any of the guests, as she recognizes the familiar clopping sound of the ghost.

No one has figured out who the ghosts of the Black Duck are. Perhaps if you stay a night, you might have an encounter with one and have the opportunity to ask them yourself—if you dare.

Once you have settled in, there are many haunted sites to see. Directions start at the Black Duck, so even if you do not stay there, you can park in the public lot just below the inn on Thames Street and start your haunted tour from there.

THE STONE MILL

One of the first strange places is in Touro Park. It is a mysterious stone structure with large archways called the Stone Mill. Upon touring New England, it becomes apparent that one is in a region of the oldest colonial influence. This area is part of the original thirteen colonies formed in the forging of this great

The Stone Mill in Newport is cloaked in history and mystery.

country of ours. It appears that there were people from the other side of the globe settling here long before the colonies of Europe broke ground.

Sitting in the center of Touro Park is a seemingly unremarkable little tower. The park is but a quarter mile square in the middle of the most prestigious city in the Ocean State. The tower, a mere thirty feet tall, has commanded the attention of some of the greatest scientists and archaeologists history has known for centuries—so much so that scholars have referred to the artifact as the most controversial building in all America.

What is the Stone Mill and what was its original purpose? In essence, that is the question everybody would like answered. It is also called the

Newport Tower, Viking Tower and Old Stone Mill. The thirty-foot-high enigma of history has eight columns and is made of fieldstone and lime mortar. Its resemblance to a Norse church and watchtower are absolutely uncanny. There are many theories that have been put forth, but only two have survived the rigorous scrutiny of time and research. The first theory is that it was built by the Norse between the twelfth and fifteenth centuries, during their many expeditions to present-day America. The second states that the tower was built by Governor Benedict Arnold, great-grandfather of the famous Revolutionary War general of the same name who turned sides on the colonial army.

Many believe that Governor Arnold erected the tower as a wind-driven gristmill in order to turn grain into flour. This theory might have ended the whole controversy if certain facts pertaining to the building did not otherwise exist. The first fact is that the structure is not at all suited for such a purpose as it is not perfectly round. Also, if one looks up into the tower, he can clearly see that a fireplace sits at what used to be a second floor. Just before the turn of the twentieth century, some remains of the floor timbers actually still sat in the stone slats of the second story. A fireplace in a gristmill can be compared to a lit match in a gunpowder room. The Stone Mill would be the only one of its kind in the world. Why would someone go to such lengths to create such an elaborate structure for such a task?

The actual reason many credit Benedict Arnold for the mill is because the very first written account of the mill in colonial record comes from his will in 1677. He refers to the tower as "My stone built windmiln." He does not state that he built it—this only proves that it was on his property. Arnold acquired the land in 1651, and the tower was already there according to many historical sources.

As we delve into history, we find that the Vikings and the Norse explored much of the New England area. Leif Ericsson and his brother, Thorvald, are said to have camped in Newport for a period of time and even named the area Vinland. William Woods of England visited New England in 1630. During this time he meticulously created two woodcut maps, one of Plymouth and one of Newport. Oddly enough, in the woodcut map of Newport, the stone tower is carved for all to clearly see.

In 1639, Newport became a founded colony, and William Coddington became the governor. Upon seeing the tower, he asked the Narragansett Indians where it came from. Their reply was that visitors with fiery colored hair built it. They came downriver on a boat resembling a seagull with a broken wing.

As more research was done on the tower itself, it was discovered that the dimensions of the tower were the same as many of the Norse towers found in France, the Northern Isles and other Scottish territories where the race flourished over one thousand years ago. The columns, windows, notches and diameters of the building are all based on a unit of measurement called the Scottish ell. This is the equivalent of three Norse feet. Its influence of structure, beams, keystones, arches and openings can be easily dated according to existing buildings throughout the world. The features of the Newport tower date it between the twelfth century and the fifteenth century, but there are some important distinctions in style that narrow its time of creation to the late fourteenth century.

In 1837 and 1839, Charles Rafn published some very important pieces in a scientific circular called *Antiquitates Americanae* based on extensive research and investigations of the stone tower. Through his findings, he deduced that the tower was built during the twelfth century. Other scholars have since asserted that it was the work of Prince Henry Sinclair of Orkney as a memorial to his adventures in the brave, untamed world in 1398. If either of those affirmations were correct, the tower would date from ninety-five to over three hundred years before Christopher Columbus even set foot on North American soil.

An excavation took place at the site in 1948. Although the carbon dating of the artifacts found at the site determined them to be colonial, not a speck of grain was discovered around or buried in the ground at the mill. A mill of such usage on a farm would have surely left behind remnants of its function for history to uncover. The items found at the site only prove once again that colonial influence was once present in the area. A painting by the famous artist Gilbert Stuart done in 1770 shows the stone tower and surrounding hills as scenery in a working farm.

There is one more bit of information to relay: the tower is reportedly haunted. People have heard screams in the tower, as well as voices echoing from the cylinder as they passed by its walls. Whether this is true, I cannot say. Whether Vikings built the edifice as a church or defense tower, I cannot say either. Let the evidence presented be your guide.

If you are on foot, head straight up the hill on Pelham Street and the park and tower will be right there. If you decide to drive this leg, you will have to do a bit of zigzagging, as there are several one-way streets in Newport.

TRINITY CHURCH

If you go back down Pelham and take a right onto Spring Street, two streets over you'll find the Trinity Church. The strange burial ground that spans its western side has been the talk of paranormal activity for years. The church was built in 1725 over an existing structure. It is the oldest Episcopalian parish in Rhode Island. The church is built entirely of wood, and the organ, donated by Dean George Berkeley in 1731, still fills the chambers with music. It was used as a garrison from 1776 to 1778. George Washington is said to have attended services there in 1781.

Among the sea captains and merchants interred there are French Admiral le Chevalier de Temay, who died in 1780, and Dr. Sylvester Gardiner, who bought an enormous parcel of land in Maine, now called the city of Gardiner. Some of those buried do not remain at rest. Ghost Tours of Newport has caught pictures of orbs flitting about in the graveyard. Misty figures and even vortexes of light have been seen and photographed in the burial ground. Whether or not you see anything, this place is creepy both day and night.

Two restaurants in proximity of each other provide cuisine that is out of this world. Perhaps that is why some from the other side have chosen to linger in them. At the corner of Washington Street and Charles Street, at the end of the square, is the La Petite Auberge Restaurant. This fine-eating establishment started its tenure as a colonial home. It still boasts the remnants of early New England life within its walls. Some of its former tenants remain as well.

DINE WITH HISTORY

La Petite Auberge

A chef passing an upstairs room after closing the restaurant came upon a man dressed in colonial navy attire seated at one of the tables. She approached the strange man to inquire why he was still there long after closing, and he faded away. The owner's wife once felt the hair on the back of her neck tingle. When she turned around, she saw the same ghost sitting behind her. Silverware often rattles at random on the tables, and the kitchen doors swing open and closed with no physical being to perpetrate their movement. Many guests have experienced the ghostly phenomena. It is not malevolent by any

means. Many think it is the ghost of privateer Stephen Decatur Sr., who was born in the house. The A&E Channel included the restaurant in one of its shows on haunted places. This makes the ghosts of the place a bit more famous than others.

Follow Charles Street a short way until it meets Marlborough Street. Take a right, and you will see one of the oldest taverns in America. Some of its ghosts are just as old.

White Horse Tavern

Francis Brinley built the White Horse Tavern in 1673 as a private residence. It became a tavern in 1687, when William Mayes Sr., son of an infamous pirate, purchased it. He then turned it over to his sister, Mary Mayes Nichols. The Nichols family ran the inn for over two hundred years before selling it. In 1901, it was turned into a boardinghouse. From there, the edifice fell into disrepair until the preservation society acquired the crumbling structure.

It was renovated and reopened as a tavern and restaurant in 1957. Since then, employees and patrons alike have rubbed elbows with specters of the

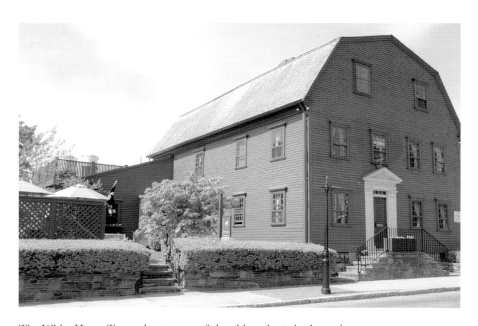

The White Horse Tavern hosts some of the oldest ghosts in the nation.

past. The ghosts of the tavern are not afraid to show themselves at any time. One little boy once saw a man in colonial clothing staring back at him in the upstairs dining room. Some of the staff also witnessed this early American phantom on several occasions.

One woman actually insisted that she get her dinners packed to go in haste. When asked why she wanted to leave so hurriedly, she retorted that the spirit of a man was bothering her and her companion so much that she could not continue her dinner. No one is sure who the ghost really is, but there is one account that might help shed some light on his identity.

About 1720, two men rambled into the inn at the witching hour in hopes of securing a room for the night. Mary and Robert Nichols had but one room for them to share. The Nicholses rose with the sun to prepare a hearty breakfast for their guests. There were, to everyone's curiosity, two empty places at the table. The latecomers had not yet risen. Mary and a house servant ascended the stairs to check on their visitors.

Carefully, they cracked open the door and peeked in. There was only one man in the room. They tried to rouse him but found him lifeless. The other lodger had vanished into thin air. There was no sign of foul play or a struggle. Fearing that he may have quickly succumbed to one of the many dreaded diseases of the time, the family buried him forthright in a modest grave. Scarlet fever, diphtheria, smallpox and consumption were certain death to those caught in their evil grasp.

The spirit appears in the room just behind the large fireplace. This may have been the room where the man died. Arlene and I held an investigation with a few other members of Rhode Island Paranormal. There were no apparitions to be seen that night, but we did get a few strange feelings, and a door swung open and then closed with no one on either side to manipulate it. There were a few voices that seemed to permeate the empty chambers upstairs, but we could not conclude whether they were paranormal or just sound from elsewhere bleeding into the rooms. Other paranormal groups have investigated the tavern. They all come out with evidence that there is something going on at the White Horse.

Two employees once heard the sound of footsteps echoing upstairs after they had closed for the evening. Each one grabbed a heavy object as a weapon and started up opposite stairs. You can imagine the looks on their faces when they rounded the corner only to run into each other. No one could have gotten by either of them without being seen. They realized they were the only people in the building—living people, that is. If it is food and spirits you crave, then the White Horse Tavern has no shortage of either.

INTERESTING COLONIAL GHOSTS

Goat Island was once used for the grazing of livestock so that the busy ports could stay free of stray animals. It is also where the largest execution of pirates in U.S. history took place on July 19, 1723, when twenty-six buccaneers were hanged at Gravelly Point across from Goat Island. From there, the executed rovers were taken to Goat Island and buried between the high and low water marks. When the moon rises high in the sky, their specters can be seen sauntering toward the shore in eternal search of those who ended their reign of terror on the high seas. A causeway just before the Visitor's Center leads to Goat Island.

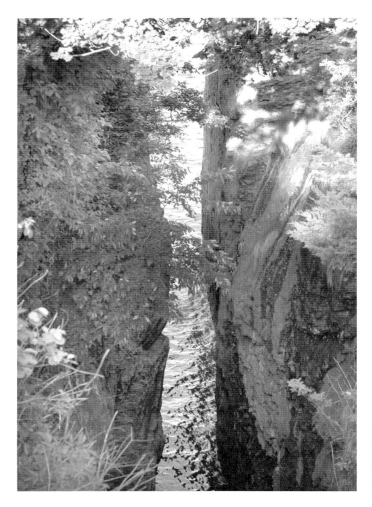

Purgatory Chasm in Middletown, where the devil threw an Indian woman over the cliff.

Fort Adams State Park is a remarkable piece of history. The fort is preserved for all to tour, and there are even ghost tours of the stronghold—with good reason, as it is reported haunted. Visitors claim to see strange movement about the fort and hear ethereal voices from within the chambers. Such a place could easily hold spirits from another era, and hourly guides believe that something is there. The place is worth visiting just for the history of it all.

Just over the line in Middletown on Tuckerman Avenue, overlooking Second Beach in Newport, sits Purgatory Chasm. The massive rock formation is said to be haunted by the spirit of an Indian woman. The woman supposedly killed a white man, and Hobomoko, the Indian version of the devil, chopped off her head and threw her remains over the cliff as a reward for her deed. For almost two centuries, her headless spirit has been spied roaming the chasm.

BRENTON POINT STATE PARK

Brenton Point State Park is a shining example of the wealth that flourished in Newport. It is also a place of mystery: why would such a parcel of land be abandoned and later given to the state? Brenton Point is named after William Brenton, one of the original settlers and political figures of the area who farmed the land in the seventeenth century. The scenery of the reef and ocean is quite breathtaking, which is perhaps why Theodore M. Davis chose this spot to build his estate. Davis was an attorney and famous Egyptologist who went on two important expeditions into the Valley of the Kings in search of King Tut's tomb.

In 1876, Davis erected his mansion, called the Reef, and settled there with his family and many artifacts from his digs in the Middle East. Many say that these artifacts were cursed. He also had lavish gardens, a massive carriage and stable house, a windmill and a laundry house that supplied heat to the mansion in the cold months. The windmill caught fire in a storm and burned. The event was blamed on the curses of the pharaohs, some of whose possessions resided in the stately mansion. Not long after, a bolt of lightning destroyed the stables. Mr. Davis rebuilt the windmill and the stables using steel beams for extra support and strength.

Despite the scenic vistas and calming sounds of the oceans waves, Mr. Davis never felt the serenity he had hoped to capture at his manor. He died in 1910, and was followed by his wife in 1915. The property lay

abandoned until 1923, when Milton J. Budlong acquired the magnificent parcel of acreage. He, too, had problems settling on the property. A mammoth divorce battle and his children not wanting to live there left the property to the elements until after his death in 1941. That's when the army took possession of the property for use as a strategic location for coastal defense. The remains of a large gun turret still grace the lawn in front of the park administration building, which used to be the servants' quarters.

In 1946, the land was given back to the Budlong family, but they refused to move back in, leaving the property derelict for undisclosed reasons until a fire destroyed the mansion in 1960. The remains of the building were torn down and removed in 1963. In 1969, the state took over the deserted estate and turned it into a public place for visitors to enjoy the remnants of Newport's past. It seems that some of the past residents still wait to greet guests as well.

Mysterious voices radiate through the air within the gardens where no physical beings are present. Voices are also heard around the stables and windmill in the same ethereal manner. Many visitors have heard the clopping of horse's hooves along the paths, yet when the unsuspecting sightseer moves over to let the equestrian by, he finds that there is no sign of a single mare nearby. Even the gnarly trees along the edge of one of the garden areas hold negative energy that seems to make people shudder and run in haste. Certain park rangers have admitted that they will not venture into the depths of the old estate after the sun's rays quit the horizon and the shadows begin

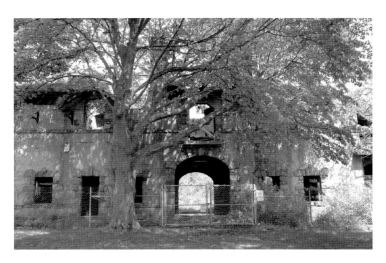

The stable ruins in Brenton Point State Park are said to still harbor some entities of the past.

to wander across the grounds. Whether it is the curse of the pharaohs or the ghosts of the past owners, Brenton Point is certainly alive with something more than history.

Brenton Point is located at the southwest tip of Newport along Ocean Drive.

GILDED GHOSTS

The mansions of Newport are no less thrilling in history and mystery. Bellevue Avenue is alive with the Gilded Age as elaborate mansions grace the landscape overlooking the sea. Many of these were actually summer homes of the wealthy. It is no wonder that some of these socialites stayed on to forever tend to their assets.

The Astors' Beechwood is the scene of one of the haunts. The mansion was built in 1851 for a New York City merchant named Daniel Parrish. The architects were Andrew Jackson Downing and Calvert Vaux. William Backhouse Astor Jr. purchased the mansion in 1881. William was the grandson of German immigrant John Jacob Astor, who became the richest man in America by investing in the fur trade and real estate. As recent as 1999, he was listed as the fourth-wealthiest American, just ahead of Microsoft's Bill Gates. The Astors then spent $2 million renovating the home for social events. Mrs. Astor would always make her grand appearance in something original and stunning. She retired from these events in 1906. She died in 1908, leaving the estate to John Jacob Astor.

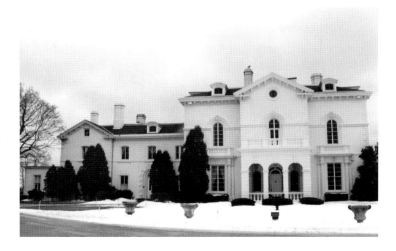

There are several tour guides in period dress at the Astors' Beechwood Mansion in Newport, but not all of them are from this time.

In 1911, John married a much younger woman, Madeleine Talmadge Force, after divorcing his first wife, Ava Lowell Willing. Their ceremony was held in the ballroom at Beechwood. The couple headed for Europe for their honeymoon. After a lengthy stay, they decided to come home on the most prominent ship of the time, the RMS *Titanic*. Mrs. Astor survived, but her husband, unfortunately, did not.

There is a theatre group residing in the mansion that holds exceptional and imaginative tours and dinners throughout the year. Many of them are set in the times when the Astors were alive. It appears that this might be why some of the deceased socialites come back. Sometimes the actors find themselves performing with a few unexpected members of the group. There is a woman in a yellow period dress who has been seen gliding around in the group's living quarters.

BELCOURT CASTLE
Touring for Spooks and Screaming Armor

One of the most famous haunts of Newport is easily Belcourt Castle. Harle Tinney has had more experiences than she can recall in one afternoon. Otherworldly tenants lurk in the bedrooms, enter the bathroom, linger on the stairs and even lodge within a suit of armor.

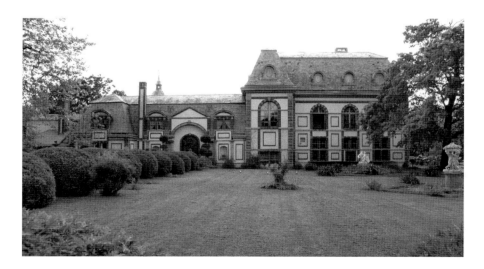

The elegant Belcourt Castle has several ghosts that refuse to leave.

The spirit of a monk has been seen many times hovering around the statue that now sits in the chapel.

Belcourt Castle was designed by Richard Morris Hunt for Oliver Hazard Perry Belmont and was built in 1894. Hunt's other designs include the base of the Statue of Liberty, the Vanderbilt homes and the United States Capitol. Belcourt Castle was fashioned after a Louis XIII hunting lodge in Versailles, France. Mr. Belmont had wide doors installed so that he could drive his carriage right into the mansion. Thomas Edison designed the indirect lighting that graces the manor to this day. The stained-glass window collection is the largest of its kind in the country and dates as far back as the thirteenth century.

The sixty-room house was completed in 1894 at a cost of $3 million. Mr. Belmont died in 1908 at the age of fifty. The property was sold in 1940 after the death of Mrs. Belmont and remained unoccupied until the Tinney family bought it in 1956 for a mere $25,000. They renovated the mansion back to its original splendor and filled it with the family heirlooms and antiques on display today.

Harle and Donald Tinney moved into the manor shortly after they were married in 1960. Soon after, Harle had her first paranormal experience. One night, she awoke to find the figure of a man holding onto the canopy post. She thought at first that they were being robbed, until the man turned around and slowly walked through the wall on the other side of the room. A few years later, the Tinneys decided to take a family drive. As they were waiting for who they thought was Donald's father to come out of the bathroom, Donald's aunt asked them why they were tardy in their departure. When they told them their reason, she simply stated that he was in the car

The suits of armor seem empty in the Gothic Ballroom on the second floor, but occasionally one becomes tenanted by a former owner.

waiting for them. A thorough investigation of the room proved there was no one there, and no one could have slipped by them, as they had their eyes on the door the whole time.

There was a wooden statue of a monk that Harle had placed near the grand staircase. Witnesses began seeing the phantom of a monk on the stairs. One night, a tour guide was telling a group about the statue when the throng became quite unnerved by the apparition of the monk behind her. Another woman inquired about the priest in the chapel. Harle told the woman that they had no priest on the premises, but the woman insisted that she had watched a man of the cloth preparing for mass. A psychic visited the castle and told Harle that the statue needed to be in the chapel or the monk would have no peace. Harle removed the statue to the chapel, and the monk has stayed in that room.

There are two gothic salt chairs in the vaulted ballroom. These chairs had backs on them when most chairs of the castle did not. Whatever happened in these chairs is not known, but they emit a furious form of energy. Tourists of the manor have touched the chairs and have felt the blood leave their hands. One woman was supposedly thrown into the center of the room when she tried to sit in one of the chairs. Since then, the chairs have been roped off for safety. No one can explain the violent force the chairs exude, but it can certainly send a person flying.

The Tinney family has several suits of armor within the castle. One suit of armor was purchased and then set up in front of the ballroom with the other suits. One night, as Harle was getting sugar from the main wing, she noticed that the stained-glass lights were on. As she approached the ballroom, she heard a bloodcurdling scream. She turned off the lights and went back to her original quest. She turned around, and the lights were on again. This time, she heard a scream that was even more terrifying than the first. She turned the lights off again, and there was a third, more hideous, scream than the second one. Donald brought the two Rottweiler dogs to take a look, but the fearless canines would not budge past the threshold.

Tour guide Virginia Smith was locking up for the evening when she heard a guttural moan coming from the direction of the armor. The moan turned into a frightening shriek that stopped her dead in her tracks. Since then, she has heard the scream several times. The Tinneys have also witnessed the armor's right arm raise just before the scream is heard. When they acquired the armor, they noticed that there was a hole

in the back of the helmet that resembled the blow of a battleaxe. They seem to think that whoever owned that armor died while wearing it and is now eternally unhappy about his demise. The hole was fixed, but the armor still wails with the unearthly shrieks of what may have been the last fearful moments of battle.

The haunts are still active in the castle. Harle related a story about a very strong presence that was active in early July. Coincidently, the first week of July was when the Belmonts would have the home opened and prepared for their summer stay.

The mansion is located at 657 Bellevue Avenue. Tours run from 12:00 to 5:00 p.m., Wednesday to Monday. Ghost tours run on Wednesdays and Thursdays at 5:00 p.m. For reservations, call 401-846-0669. With haunts on every corner it is no wonder Newport is always bustling with those you can see and those you can't.

Rooms with a Boo

Admiral Farragut Inn
31 Clarke Street
Newport, RI 02840
1-800-524-1386
www.innsofnewport.com
*The inn is reported to have the ghost of a seventeenth-century soldier roaming its halls. Guests have felt the presence, and a worker once had the hair on his arms stand on end every time he entered a room.

Cliffside Inn
32 Seaview Avenue
Newport, RI 02840
401-847-1811
www.cliffsideinn.com
*Reportedly haunted by the ghost of Beatrice Turner, who lived in the house until her death at age fifty-nine. She is seen in her long dress by staff and guests alike. The luxurious inn is painted in vibrant welcoming colors and offers a fireplace in each guest room.

SALEM/MARBLEHEAD, MASSACHUSETTS
More than Just Witches Brewing

Salem has forever been the Halloween capital of the world, but no one ever ventures out to its sister colony, Marblehead. After we have toured the Witch City, we shall meander to the quaint town of Marblehead, where yachts once ruled the moors and screams of witches and wraiths echo in the sea breeze.

Salem was founded in 1626 at the mouth of the Naumkeag River and assumed the name of the tributary. In 1629, Roger Conant and other fishermen from Cape Ann incorporated the colony and renamed it Salem, a translation of the Hebrew *shalom* and the Arabic *salaam*, both meaning "peace." The Massachusetts Bay Colony appointed John Endicott as its first governor. Salem's boundaries stretched much farther than they do today and included such towns as Danvers, Topsfield and Marblehead.

Salem's maritime history is an integral part of its heritage, much overshadowed by the witchcraft hysteria of 1692. It is hard to imagine that the Atlantic's ebb and flow once rubbed the land where Derby Street now sits. The growth of the merchant trade in Salem made it the center of trade in the colonies and the United States until the War of 1812. After that, shipping went into a decline and Salem could no longer keep up with the ports of New York and Boston. Now, only remnants remain of that prominent period in Salem's history. Salem has become known as the Witch City. Even the police cars sport the familiar black-cloaked figure riding a broom on their doors.

Recently, the city has been trying to focus on more than just witches in an attempt to revive its maritime—and even more enticing, its haunted—history. This chapter focuses on those places where the ghosts of Salem's past still reside, despite the ever turning wheels of progress and time. The Visitor's Center has plenty of maps and information on all the other attractions, so do not hesitate to stop in and relish in everything Salem has to offer. The guide to Salem included here is a walking tour, but if you decide to visit Marblehead, it is only a short drive from the Witch City.

Park in the garage on St. Peter Street. As you exit the lot to the left, the old Salem jail sits at the corner of St. Peter and Bridge Streets. This is where

Albert Desalvo, the alleged "Boston Strangler," was once housed. The jail was built in 1811 and enlarged in 1884. It closed in 1991. Ghosts are seen moving by the windows, and lights flicker from within the panes when there is no electrical current on the premises. It is reported to be the most haunted site in Salem but is also fenced in for safety.

GHOSTS OF THE WITCHES PAST

Just behind the jail is the Howard Street Cemetery. In the far left corner, Giles Corey was crushed to death during the witchcraft persecutions. He never admitted to witchcraft, but in his dying breath, he cursed the town and all of the sheriffs to follow. It is known that every sheriff of Salem suffered some infliction, either causing him or her to retire or die while in office. Corey's ghost is said to roam the cemetery, and when spied, ill fortune awaits the city that put him to sleep. Other misty figures and orbs have been photographed within the walls of this burial ground. The cemetery was opened in 1801, and the first interment was of a second mate aboard the *Belisarius* named Benjamin Ropes, who died tragically, oddly enough, after being crushed to death by the foretopmast of the ship.

Continue up Howard Street and take a left onto Brown Street to the Salem Witch Museum. There is a red stripe along the sidewalk that leads to most of the sites on the walking tour. Once inside, wax figures play out the trials as an ethereal voice narrates the lit scenes towering overhead for visitors standing in a dark room. The museum staff has mixed feelings about which figures are dormant and which may be the cause of the

Howard Street Cemetery, where the vengeful spirit of Giles Corey is seen as a foreboding omen.

The Salem Witch Museum is alive with history and, perchance, a few historical characters as well. *Photo courtesy of the Salem Witch Museum.*

footsteps heard in the exhibit room long after the place has closed. They also attest to voices emanating from the rooms when no one else is around. There is a fee for the museum, but the gift shop is great. Who knows whom you might see floating around?

Peabody Essex Museum
Houses Still Occupied

Straight ahead down Essex Street is the Peabody Essex Museum (PEM) Neighborhood. There are several houses within this museum that are worth checking out. Whether they are actually haunted is a matter of conjecture. The museum states that they are not, but witnesses say otherwise. I cannot claim that they are haunted as I have never seen a ghost during my visits. I have, however, seen a wondrous place where history rambles along. Haunted or not, it is certainly worth the visit.

The first house of interest is a brick, Federal-style home built in 1804–05 by merchant John Gardner Jr. Captain Joseph White, who lived there until his untimely demise in April 1830, later purchased the house. Two nephews hired someone to kill the old man in hopes of gaining his inheritance. The plan did not go well, and they were caught. David Pingree and his heirs owned the home from 1834 to 1933.

The museum staff has not had any encounters with ghosts, but there are people passing the home or touring who swear that they see things from time to time. Reported activity at the estate includes ghostly faces peering out the second-floor windows, footsteps heard behind people touring the house when there is no one there and even the residual reenactment of the murder of Captain White. There is a great photo of a face in the window on the Salem Night Tour website. The tour actually starts across the street from the house at Remember Salem Gift Shop. Michael Martin, Captain "Light Foot," leads visitors on an unforgettable and informative journey into Salem's dark side in the dark of night.

Martin would know a lot about this subject as his shop sits on the former homesite of Phillip English, an accused witch who fled with his family from the persecutions. The basement of the building is host to some negative energy, which throws items and screams at anyone who enters the cellar. The captain will be more than happy to share more with you as you visit his tour and shop.

Another home in the museum that is reported haunted is the John Ward House, not to be confused with the Joshua Ward House. This seventeenth-century home was moved to its present location in the museum and is a historical focal point due to its architecture. Some have seen a phantom face looking out the windows long after the home has been secured for the evening. This home is also featured on the Salem Night Tour.

Also owned by the PEM is the Ropes Mansion. Nathaniel Ropes was a judge during the witchcraft trials. This stately edifice has beautiful gardens and some say a ghost as well. Nathaniel's wife, Abigail, burned to death in the house when her nightgown caught fire. Her ghost is now seen roaming the rooms of this lavish estate. The home is located near the corner of Essex and Cambridge Streets at the end of the red walking tour stripe.

Take a moment to visit the museum. The trip through time is a thrill in itself, ghosts or not.

OLD TOWN HALL
Burning the Midnight Oil

The Old Town Hall at 32 Derby Square was built in 1816 but was replaced by a newer building in 1836–37. It has been plagued by ghostly activity from the start, both inside and out. Objects move about on their own, and visitors or passersby have seen figures gliding in front of the windows when the building is supposedly empty. Some have photographed what

look like misty faces peering out the windows. Perhaps the ghost(s) are in search of the four wraiths seen wandering Front Street just behind the haunted hall. Many have come across the gaggle of ghosts and have even had experiences with one in particular—an angry woman dressed in seventeenth-century clothing.

Joshua Ward House
Look but Do Not Enter

The Joshua Ward House at 148 Washington Street is labeled as one of the most haunted houses in America. It is a private building, home to Higginson Book Company. Visitors can at least stroll by and get a glimpse of the home while perusing its history. Captain Joshua Ward built the home between 1785 and 1787. It was erected on the foundation of George Corwin's former house. Corwin (1666–1696) was the high sheriff during the witchcraft trials and carried out the arrest and executions of the accused, starting with Bridget Bishop, the first to be executed on September 16, 1692. He was also responsible for the pressing of eighty-year-old Giles Corey. The curse wrought upon Corwin, and all Salem sheriffs thereafter, took effect soon after Corey's execution. Corwin died suddenly of a heart attack at age thirty. He was buried in the cellar of the home for fear that the angry villagers would dig up his grave and tear his remains to shreds. It was not until years later that his body was moved to the Broad Street Cemetery, the second oldest burial ground in Salem.

Old Burying Point
Where the Oldest Ghosts Roam

Follow Front Street east to the Old Burying Point Cemetery. This is where many of the first settlers of Salem are buried, and more important, it is the location of the Witch Trials Memorial. The burying yard, established in 1637, is the oldest in Salem. Among those resting here are Richard More, an original passenger on the *Mayflower*, and John Hathorne, one of the judges who put the accused witches to death. The memorial abuts the burial ground and has granite benches adorned with the names of all the witch trial victims. Follow Charter Street to Hawthorne Boulevard and take a right and then a left onto Derby Street.

There are many attractions and shops along Derby Street that can fill an afternoon. This is also where Salem's maritime history comes into view. Derby Wharf is the long wharf with the small lighthouse. The wharf was originally built in 1783 and extended in 1809. The lighthouse was built in 1871 to complete the system of signals for Salem Harbor. The three-masted, square-rigged merchant vessel is an exact replica of the original *Friendship*, built in Salem in 1796–97. The ship is not haunted, but claims of the lighthouse having a ghost or two have been circulated.

Note the strange mist winding around the graves in Old Burial Point heading toward Judge John Hathorne's stone. This photo was taken after dark outside the cemetery wall.

Across from the wharf is the old Custom House, built in 1819. This is where U.S. government officials issued permits to land cargo and certificates for sailors and ship measurements and where merchants paid customs duties. The revenues helped build and maintain lighthouses, protect shipping and provide medical attention to mariners. The Custom House is the setting for the opening pages of the 1850 book *The Scarlet Letter* by Nathaniel Hawthorne, and with good reason. Hawthorne worked as a surveyor there from 1847 to 1849, until he was fired from the position for spending too much time writing his novel instead of working. Tourists and staff hear disembodied voices of ship captains conversing about their treasures from abroad. Footsteps echo through the halls and rooms where no living being is present, and strange lights appear in front of visitors, as do floating orbs. Maybe Hawthorne knew a bit more about the place than he let on!

A BREAK FOR SOME HAUNTING FOOD

There are a few restaurants in Salem that boast more than great cuisine. Many notable paranormal groups have investigated these establishments, and they all have one word to say: haunted.

Lyceum Bar and Grill

The Lyceum Bar and Grill at 43 Church Street was a former lecture hall where such notables as Thoreau, Hawthorne and Emerson lectured. Alexander Graham Bell made the first public telephone call from the building on February 12, 1877. The restaurant was established in 1989, but before all of this, it was the home and orchard of Bridget Bishop, one of the most famous women accused of witchcraft in 1692. It is rumored that her spirit still roams the building, and when she is present, a strong smell of apples permeates the restaurant. The second floor is reserved for large functions and weddings. That is where the spirit of a little girl resides. The restaurant has a photo of the child ghost, which it shows to ghost enthusiasts. The cuisine is distinct and delicious.

Spirits: Good Name for a Haunted Place

According to New England Ghost Project, Spirits at 300 Derby Street harbors a few ghosts as well. One of the ghosts is said to be Bridget Bishop, who is also said to haunt the Lyceum Bar and Grill. The food is reasonably priced and the atmosphere casual.

THE HOUSE OF THE SEVEN GABLES

**Thanks to Amy Waywell of the House of the Seven Gables for sending this historically accurate text on Salem's most celebrated attraction.*
Among the most famous of all Salem stops is the House of the Seven Gables. No tour of Salem would be complete without a stop at this historic site. Captain

The House of the Seven Gables has been immortalized in prose and poetry. But is it haunted?

John Turner, who purchased the lot from Widow Ann Moore, originally built the home in 1668. Turner added a kitchen lean-to and a gable to the house in the early 1670s and later, in 1676, a very large wing that includes the last three gables. Unfortunately, he died in 1680 at the age of thirty-six, leaving the estate to his wife, Elizabeth, and ultimately to his eldest son, John Turner II, who was nine years old at the time of his father's death.

The house remained in the family for three generations. Unfortunately, John Turner III incurred significant financial losses in the years following the Revolutionary War and was forced to sell the home in 1782 to Captain Samuel Ingersoll. In the 1790s, the Ingersolls remodeled the seventeenth-century mansion to conform to Federal-style architecture. They removed four of the gables and the kitchen lean-to added by John Turner. The captain's daughter, Susannah, was second cousin to a young Nathaniel Hawthorne. Despite the twenty-year age difference, they became very close friends, and Nathaniel dined at the home frequently. It was during these meals that Susanna's stories about the house, with all seven gables, inspired the setting for Hawthorne's novel *The House of the Seven Gables* and a collection of short stories called *Grandfather's Chair*.

Hawthorne died in 1864, six years after Susannah. The home went to her adopted son, Horace Connolly (Ingersoll), who was forced to sell it in 1879 due to bad business decisions. From there, things went downhill for the legendary abode, which sometimes stood vacant and at one point almost became a tenement house, until Henry Upton bought the property in 1883. Caroline O. Emmerton purchased the property in 1908. With care and diligence, using original deeds and plans, Emmerton and famed Colonial Revival architect Joseph Chandler restored the home to the style of Captain Turner's era and opened it in 1910 for tours. All but three of the gables that tourists see, although in their proper locations, are not original, and Hawthorne never saw them in his lifetime. Emmerton then purchased two other buildings—the Hooper-Hathaway House and Retire Beckett House—and had them moved from elsewhere in Salem to the property. Finally, in 1958, the museum moved Hawthorne's birthplace to the property from Union Street so that it sits adjacent to the House of the Seven Gables.

Emmerton restored the house with a specific purpose in mind. She replaced the missing lean-to and gables so that she could offer tours through the house that focused on the plot of the novel. The most notable addition that Emmerton made was the now-famous Secret Staircase, added in 1908 for the purpose of the tours. The money that she collected from tourists for tours was used to fund her Settlement House. Settlement houses in the early

twentieth century were places where new immigrants to the United States could come to learn English, as well as job and household skills. Emmerton's early Settlement House offered various educational and social programs for the largely Polish Americans in the Derby Street neighborhood. A century later, the museum still uses admission dollars to run the House of the Seven Gables Settlement House. Today, the programs offered at the Settlement House include educational programs for children and seniors.

While the property is not haunted by any actual spirits, it does have a famous fictional ghost. In Hawthorne's novel, the Pyncheon family falsely accuses Matthew Maule of witchcraft in order to acquire his house and property. Before he is hanged, Maule declares to Colonel Pyncheon, "God will give you blood to drink!" Colonel Pyncheon then replaces Maule's house with the House of the Seven Gables. However, the day the house is finished and opened to the public for a party, Colonel Pyncheon is discovered dead in his study, with blood dripping out of his mouth and down his shirt. The ghost of Matthew Maule had his revenge and would continue to haunt the Pyncheons and the house for many generations.

The tour includes the mansion, the three-season Colonial Revival gardens, Hawthorne's birthplace and the museum store, located in the Retire-Beckett House, as well as breathtaking views of Salem Harbor. Visible from the grounds is the town of Marblehead, another seventeenth-century colony worth a visit.

I must note for posterity that some claim to have seen spirits in the house, but the staff has never witnessed anything unusual. A haunting can be in the imagination of the beholder or sitting in the wings waiting for the right people. Perhaps it is history that creates a moment where one could just imagine the past residents roaming the beautiful estate. You decide.

MARBLEHEAD
Yachting Capital of the World and Screaming Specters

Marblehead was founded in 1629 and was well noted for its fishing trade. It was named mistakenly for the rocky ledges that looked like marble but are actually granite. It is the birthplace of the American navy. It also has the distinction of being considered the yachting capital of the world. This coastal domain perched on the rocky precipice overlooking the Atlantic Ocean is a wonderful afterglow of the visit to Salem. The homes along the shore almost bump into one another when a strong sea breeze wisps about their outer walls. It is amazing how they cluster together in a dense yet scenic array.

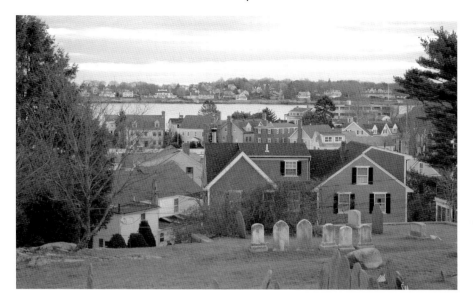

Old Burial Hill in Marblehead is one of the most scenic burial grounds in the country. It also has a lot of New England legends attached to it.

One of the more interesting places to visit is Old Burial Hill, which stands as one of the most prolific graveyards in New England. It sits on a vast deposit of granite. Over six hundred Revolutionary soldiers are buried there, and there is a monument to the sixty-five men who lost their lives at sea when a hurricane took eleven fishing vessels from Marblehead on September 19, 1846, in the Great Banks of Newfoundland.

Water for a Witch and the Birth of a Banshee

There is a small pond that abuts the burial yard named Red's Pond after Wilmot Redd (also spelled Reed or Red), the only accused witch from Marblehead to be executed in 1692. As the legend goes, Redd was said to have the power to curdle milk fresh from the cow's udders. She was feared by the townsfolk and was immediately turned over to the magistrate on charges of making a pact with the devil. She was arrested on May 28, 1692, and executed on September 22 that same year. As she went to the gallows, she cursed the town, and to this day, her cry, "This town shall burn!" echoes through the shoreline shanties. Those words are but one of the ominous screams that "Marbleheaders" must eternally endure. The other is from the Screaming Lady of Marblehead.

The memorial stone to Wilmot Redd of Marblehead, the only town citizen to be executed for witchcraft in 1692.

Red's Pond is named in honor of Wilmot Redd. Her home was reported to have been where the pond sits now.

Corsairs just off the coast of Marblehead overtook a ship carrying wealthy passengers. One woman wore a ring of substantial size. The pirates could not remove the ring, so they attempted to cut off her finger. She leapt overboard and swam to shore. Another version states that she was the daughter of a fisherman who was out to sea when the freebooters landed and captured her. Either way, as they brutally attacked her, she screamed, "Lord save me!

Mercy! Oh Lord Jesus save me!" The residents of the cove heard the shrieks but for some reason did not attempt to save the woman. In the morning, they found her and buried her near where she was murdered. Now every year, the ethereal cries ring out along what is now Screeching Woman Cove as the locals relive that foreboding night centuries ago when the Screaming Lady of Marblehead made her first shrieks.

The Magician of Marblehead

John Dimon was born about the time of the Salem Witch Trials. If one takes into consideration that he was known for his magical conjuring then perhaps there *were* actual enchanters among the colonists. Dimon owned land near the Old Burying Ground and would stand on the highest precipice during the raging tempests and call out for the powers that fueled his magic. Many times, the ships out at sea were subject to his influence. If he took favor to a certain captain, the ship would see port no matter how dreadful the storms it encountered. If the captain or crew were on his bad side, the vessel was never seen again. It is interesting to note that he was the grandfather of renowned fortuneteller Moll Pitcher, who was born in Marblehead about 1736 and died in Lynn in 1813. Pitcher came from a long line of wizards and was known the world over for her abilities in reading tea leaves and predicting the future. She is buried in West Lynn Burial Ground, where a monument, erected in 1887, marks her grave.

BEWITCHING PLACES TO STAY

The Hawthorne Hotel sits right in the heart of Salem across from the Salem Common. It also has a few haunts that make it quite enticing. Room 32 has a very active ghost, and the ship's wheel in the dining room sometimes creaks to life as if someone is still at the helm. Visit www.hawthornehotel.com or call 978-774-4080 for more information.

The Coach House Inn
284 Lafayette Street
Salem, MA 01970
978-744-4092 / 1-800-688-8689
chisalem@comcast.net

The Marblehead Inn
264 Pleasant Street
Marblehead, MA 01945
1-800-399-5843
info@marbleheadinn.com

The Stepping Stone Inn Bed & Breakfast
19 Washington Square North
Salem, MA 01970
978-741-8900 / 1-800-338-3022
*Salem's Heritage Walking Trail begins just a few feet from its front door. Free passes to the Salem Witch Museum next door are offered with a two-night's stay or more. Call for details.

THE TOUR

Salem Night Tours is the number one tour of Salem. The guides are friendly and have extensive knowledge of Salem. Lantern-led tours begin nightly at 8:00 p.m. at Remember Salem Gifts, 127 Essex Street. Call 978-741-1170 for more information.

Remember Salem is on the site of the former Phillip English home. English and his wife fled Salem to avoid the witchcraft persecutions. A malevolent entity has been experienced in the cellar. It is also the home of Salem Night Tours.

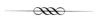

PORTSMOUTH, NEW HAMPSHIRE
Ghosts on Every Corner

New Hampshire's seacoast is the smallest in the United States, yet the amount of history and mystery that linger on this minute brim could rival the largest seaboards on the planet. It would take volumes to describe in depth the timeline of this region, aptly called the "Seacoast." Let's get started on our journey through the most fantastic place in all of New Hampshire, if not New England.

There is no evidence that the Vikings actually visited here, but it is assumed that they made a stop on their way down the coast to what they called Vinland, now known as Rhode Island. In 1614, John Smith (yes, the John Smith of Pocahontas fame) sailed to the coastline and discovered the Isles of Shoals. He named them "Smythe Isles," but later settlers gave the islands their present monikers. In 1630, Captain Walter Neal sailed up the Piscataqua River and settled among the thick growth of wild berry bushes. He named the area Strawbery Banke and erected a communal structure called the "Great House." By 1640, 170 people were working in the area, which was considered part of the Massachusetts Bay Colony. In 1653, the court granted a petition to change the name of the settlement to Portsmouth, as residents felt their port at the mouth of the river was as good as any in the colonies.

Portsmouth was in the forefront of the shipping trade until the War of 1812, when the embargos on trade brought the city to a standstill. The war brought on new trade for the people of Portsmouth—privateer ships. These sleek, fast vessels were made to run down and capture the slower trade ships of the time. After the war, Portsmouth's trade fell into a decline and industry took over. The history of the area is truly illustrious and full of characters. Many of them still wander along the old salty streets of the Seacoast region.

HITHER A BOO, THITHER A BOO

Portsmouth is the flagship of haunts along the seacoast. It seems there is a ghost on every corner, and many of these spirits hail from as far back as the

The John
Paul Jones
House and
Museum in
Portsmouth.

seventeenth century. Let's start at the John Paul Jones House. This museum is home to the Portsmouth Historical Society and has a remarkable history. Captain George Purcell built the house in 1758 for his wife, Sarah Wentworth Purcell. When George died, Sarah began letting rooms to make ends meet for her and her children. One of those boarders was famous Patriot John Paul Jones, who stayed there while his ship, the *Ranger*, was being outfitted for battle. He roomed there again in 1781. It is rumored that he had an ongoing affair with Sarah. By 1919, the home had fallen into disrepair and was acquired and renovated by the historical society. That is when the spirits were roused from their eternal repose.

Countless passersby have seen the face of a woman peering out of the windows of the museum after it has been secured for the night. Many believe it is the spirit of Sarah looking for her husband or Admiral Jones. There is also a presence lurking in one of the upstairs rooms of the museum. A cabinet door swings open when visitors are present. The room that John Paul Jones slept in has a likeness of him at a desk. This is where paranormal investigators have seen his spirit as well. The museum guides have heard the back door open and close but, upon investigation, found no one there. The museum is open during limited hours, and there is a small tour fee, but the chance to see an American hero from centuries past is priceless.

Get on Route 4 toward Portsmouth and take Exit 1. If you follow the signs for Strawbery Banke, you will come to the corner of Middle and State Streets. The museum is at 43 Middle Street. There is plenty of parking on the street and in lots. Call 603-436-8420 for more information.

THE LIONS SIT WATCHING

The towering ornate structure next to the museum is the Rockingham Hotel. This was once the home of Woodbury Langdon, older brother of Governor John Langdon and Revolutionary War judge. The original home was destroyed in the great fire of 1781 but was rebuilt by 1785. It was considered one of the most distinctive brick houses in New England. Langdon died in 1805. On November 1, 1833, Thomas Coburn opened the doors as a hotel. In 1870, entrepreneur and brewer Frank Jones bought the building and enlarged it. Another of Portsmouth's disastrous fires destroyed all but the octagon room of the hotel in 1884. It was rebuilt, sparing no expense. It later became apartments and finally was converted into a condominium in 1973. In 1975, the Library Restaurant opened for business in the old study of the graceful estate.

Many people have come and gone over the centuries, but one seems to remain as a permanent tenant. There is a female specter that wanders through the chambers of the building. In the Library Restaurant, servers present your bill within the pages of ancient tomes. Staff members, as well as those living in the building, have seen the illustrious lady from time to time. In fact, Esther Buffler, Portsmouth's first elected poet laureate in 1998, wrote about the ghost after she saw it in her apartment. The ghost is thought to be that of a woman who drowned just down the street from the hotel. Witnesses smell a strong odor of seaweed just before she appears in her shimmering white dress. Others claim it is the spirit of Sarah Purcell, wandering the building in search of Woodbury, who gained possession of her house in 1783 after the great fire damaged the home. Maybe she wants it back. No one knows for sure, but someone is making an appearance at the hotel—and not just for the fine food and drink.

THE MUSIC HALL
*Phantom Performances**

After some food and spirits at the Rockingham, you might want to take in a show at the Portsmouth Music Hall located just behind the old hotel. The hall was built in 1878 on the site of the previous hall, which burned in 1876. Since then, many diverse acts have graced the stage, ranging from vaudeville to big band. Some liked the shows so much that they have never left, having taken a ticket to eternal entertainment.

The Music Hall in Portsmouth has a few ghosts that are still performing their roles long after their curtain calls to the other side.

Patrons have seen shadows pass in front of them in the rows during shows and dark figures moving across the walls when everyone is seated. Phantom footsteps can be heard clopping in the halls when the building is otherwise empty. Witnesses have seen the stage curtains swell and start moving as if someone was about to emerge from behind. Upon investigation, there is no visible being behind them. Some patrons have seen a man on the stairs in the hall. At first, they assume it is an actor setting the tone for the evening—until the figure vanishes in front of them. During some recent renovations, a painting of a masked character wearing a colonial hat was found. Some of the staff feel convinced that this is the ghost of the hall.

Another point to mention is that it was thought that the Music Hall was built over a portion of an old Negro burial ground. In 2003, that rumor was confirmed when workers dug up some coffins while working on the street. Since then, they have found many more and relocated them. There is a plaque honoring the Negro population and those who lived and died in Portsmouth. Archaeological investigations are still going on to find out more about the burial ground and how large it actually is.

Portsmouth Music Hall (603-436-2400) is located at 28 Chestnut Street in Portsmouth.

BAKERY, BISTRO AND BOO

Have a snack or sandwich and tea with a ghost just a few blocks from the music hall. The Sheafe Street Inn and Ceres Bakery on the corner of Sheafe and

Boo if by Sea

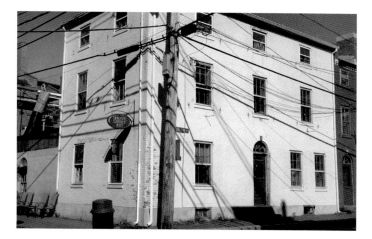

The historical Sheafe Street Inn is home to many strange accounts of past entities wandering within its walls.

Penhallow Streets is a nineteenth-century inn that has since been converted into apartments and a dining room. The bakery has been next to the inn since 1983. Renovations helped connect it with the first floor of the old hostel. The inn has a strange past, relating to the ghosts that reside there.

One of the first owners slept on the first floor of the inn. One evening, as she sat on her bed, something heaved her from the divan onto the floor. She did not stay for a second round but instead made haste for a friend's house, where she stayed the night. A phantom hunter has been witnessed at the inn. A guest once encountered the apparition following him with a band of dogs by his side. Other witnesses attest to seeing the same vision but in horseman's dress. When the building was being renovated, very old equestrian gear was found in one of the walls.

Another ghost was that of an unseen entity that disliked sailors. Unsuspecting sailors would find themselves wrestling with invisible energy that would attack them as they passed the inn. John Haley Bellamy, the famous carver of eagles, died at the inn on April 6, 1914. His spirit is blamed for breaking liquor bottles and opening windows in the upstairs chambers.

Meanwhile, the bakery has its own goings on. Cooks get the feeling that someone is watching them, and they have seen shadows flit about when they are alone. Tools and utensils move on their own, as if someone is being overly tidy. Footsteps have been heard in the dining room when the bakery is otherwise empty. Good food and blasts from the past—what more could you ask for?

The bakery (603-436-6518) is open Monday through Friday from 7:00 a.m. to 5:00 p.m. and Saturday from 7:00 a.m. to 4:00 p.m.

Irish Fare and a Chance of a Scare

If it's Irish fare and a good stout you are looking for, McMenemy's is the place to go. This is the location of the former Molly Malone's, a favorite stop for all who wanted a taste of Irish fare and phantom. The building was once a bordello, where ladies of the evening would beckon sailors on shore leave to their rooms. People passing by the building have seen the spectral women dressed in nineteenth-century attire looking out the windows for clients on the streets below. The building was once used as an apothecary, and a ghost dressed in a white coat has been seen in the basement by staff members.

New England Ghost Project (NEGP) and author/tour guide Roxie Zwicker investigated the pub in September 2007 for a live radio show. Ron Kolek of NEGP is a very good friend and was more than happy to share his findings. Kolek placed two dollars on a table in an attempt to lure the ghostly madams, but nothing happened. In the basement, they picked up a strong EMF reading, and psychic trance medium Maureen Wood picked up the presence of a few revenants in the building.

The ladies' bathroom door upstairs has been known to lock and unlock at will from the inside. Kolek captured a photo of the bathroom door latching itself while holding a vigil in the little water closet. Although they did not witness the occasional dishes and glasses flying off the shelves or mugs sliding across the bar, they walked away convinced that there are a few permanent revelers at the old pub.

The pub is located at 177 State Street in Portsmouth. Call 603-436-4747 for more information.

History and Mystery
Strawbery Banke Museum

The Strawbery Banke Museum is a must see during a trip to Portsmouth. The museum traces over four hundred years of one of America's oldest settlements. The forty buildings lie along ten acres, and most are on their original foundations. The museum came about in 1957, when Portsmouth librarian Dorothy Vaughan made a riveting speech about the demolition of the archaic buildings in the wake of urban renewal. In 1958, Strawbery Banke Inc. was formed and given the land where Puddle Dock sat. The buildings around it were spared, and others would soon be moved to accommodate

the growing tide of heritage Portsmouth began to gain. Strawbery Banke opened to the public in 1965 and has remained one of the only historic neighborhoods in the country where visitors can get a glimpse of America's growth over the last four hundred years.

The oldest home at the museum is the Sherburne House (circa 1695–1703). It would seem rather disappointing if this distinctive seventeenth-century home were not haunted. Captain John Sherburne built the home but died a few years after its completion. The later addition is evident in the asymmetrical exterior. The ghost is thought to be that of Henry Sherburne's daughter, Rebecca. She was one of eight children and mute. Her ghost is seen in the windows and the rear garden, where she is reported to be guarding over her former home.

The Dunaway Restaurant at the corner of Marcy Street, two houses over from the Sherburne House, was built in 1967 on an existing foundation and dedicated on June 10 of that year by First Lady Mrs. Lyndon B. Johnson. The ghosts must have felt honored and decided to take up residence there, as many have witnessed the wraith of a minister strolling outside the building around dusk. He has also been seen looking out the window before vanishing into thin air.

Some say that Stoodley's Tavern is also haunted by its former residents, but let's leave that for you to decide. Finding your own ghosts is what makes these adventures so memorable. The Chase Home was also once reported to be haunted, but that seems to be a case of mistaken identity, as there are two Chase Homes in Portsmouth. The other is a private building.

Strawbery Banke (603-433-1100) is located on Marcy Street in Portsmouth. Take a right at the end of State Street onto Marcy Street.

READS AND WRAITHS
The Portsmouth Public Library

The library has three ghosts that frequent its rows of tomes. One of them is the ghost of a child that lurks in the upper balcony. Looking up from the Reference Room, witnesses have seen the little figure with light curly hair backing away from the railing and vanishing. Light footsteps and shuffling are also heard, and shadows are often seen moving about the area of the balcony.

The second ghost seems to be on eternal watch at the library. There is an invisible spirit that always tells people to "Hush" when they are making a

racket in the Special Collections Room, and perusers of the collections often feel like someone else is there with them.

The third ghost wanders across from the health food store to the Reference Room door on Islington Street. Instead of using the door, he walks straight through a wall. Perceivers of this occurrence notice that he is dressed in modern attire and time his arrival around lunch hour.

The library is located at 8 Islington Street in Portsmouth. Get back on Marcy Street and take Court Street to Middle Street. Make a right on Middle Street and then a left onto Islington Street. The building is now vacant, but the ghosts may still be making their rounds.

CEMETERIES WITH HISTORY AND MYSTERY

If you cross Marcy Street from Strawbery Banke, you will see Point of Graves Burial Ground on Mechanic Street. It is not massive by any means but has secured a large place in Portsmouth legends and folklore. Captain John Pickering donated the land for the purpose of a burial ground in 1671 under the condition that his livestock have full privileges to graze among the stones. In essence, they were the caretakers of the grass in what is now the town's oldest burial yard.

Some of the stones, dating back to the seventeenth century, are adorned with a skull and crossbones, a common illustration for tombstones back then. Visitors to the graveyard have heard footsteps along the rows or have been touched by invisible beings. Paranormal activity seems to be prevalent around the grave of Elizabeth Pierce, who died in 1717. Some claim it is because

Three graves— Elizabeth's in the background and two children's in the foreground—are said to be haunted in Point of Graves Cemetery.

she is buried alone and is looking for attention or perhaps company. She has been known to touch or nudge those who come close to her place of eternal repose. Roxie Zwicker of New England Curiosity Tours was once pushed by something unseen. Another place of ghostly presence is a stone bearing the names of two children who died during the yellow fever epidemic of the late eighteenth century. People who walk by the grave are often overcome by an unexplainable sadness.

One more place in the yard of particular reverence is the Vaughan tomb. Strange lights and a green glow emanating from the monument have shown up on film. There has been no explanation for the phenomena, and it shows up in the negatives as well. If Point of Graves gets your hair standing on end, then by all means take a trip to the next destination, South Cemetery.

South Cemetery, located on the corner of South and Sagamore Streets, is a conglomeration of four cemeteries melded into one massive necropolis. The first, Cotton Ground, was established in 1671 and also served as a training field for the colonial militia. Proprietor's Cemetery was added in 1831, followed by Harmony Grove in 1847 and finally Sagamore Cemetery in 1871. South Cemetery is a paranormal investigator's castle in the sky, as there are so many places where anomalies have been seen and photographed or spirit voices (EVPs) recorded. Visitors claim to have been touched by imperceptible entities. Upon entering the South Street gate, activity begins to register on EMF meters and recorders.

One of the places of most concentrated activity is about three hundred feet south of the small pond near the center of the cemetery. That is where Ruth Blay was buried after her tragic execution. Blay, a former schoolteacher, hid her dead infant under the floorboards of a small schoolhouse in South Hampton. Some children found the infant wrapped in cloth, and the authorities arrested Blay for murder. She claimed the infant was stillborn but was tried, convicted and hastily hanged for the deed on December 30, 1768. A timeline account of Portsmouth stated that the year was 1739, but a check through many official records show that two other women, Sarah Simpson and Penelope Henry, were hanged on December 27, 1739. The sheriff who presided over all three hangings was a man named Thomas Packer. The town sided with Blay, who had proclaimed her innocence throughout the trial, but the sheriff was adamant in his conviction. Accounts state that he did not want to be late for dinner. Word of reprieve unfortunately arrived minutes after the execution. The residents became so outraged that they hung an effigy in front of Packer's home with a plaque saying, "Am I to lose my dinner this woman for to hang? Come draw away the cart, my boys—don't stop to say amen."

The graves of the two women murdered on Smuttynose Island in 1873. Although they are long buried, it is reported they are not necessarily at rest.

Many have photographed strange forms and orbs hovering around the area of Blay's grave. Perhaps she is still trying to prove her innocence or searching for the man who rashly sent her to her untimely demise.

Another place of haunted repute is the Harmony Grove section, where the graves of Karen Anne Christensen and her sister-in-law, Anethe Matea, sit. The two were brutally murdered on Smuttynose Island on March 6, 1873. A German immigrant named Louis Wagner was blamed for the murders, as he was a lodger at the home of John and Maren Hontvet at the time. According to the *Windham County Transcript* from June 12, 1873, Mrs. Hontvet escaped and hid in the snow until morning, when she sounded the alarm for help. According to court records, the murder was so violent that the axe handle broke during the blows to the women. Wagner swore his innocence all the way to the gallows, where he was executed on June 25, 1875. The area around the graves has a lot of energy, and investigators have gotten high readings on their equipment.

There are other places of reverence, such as the small cemetery closest to Clough Street, where energy and anomalies are seen, and the eastern portion of the burial ground, where phantom soldiers have been witnessed. Residents of the area attest to the phenomena that occur within the cemetery, but it must be visited before 6:30 p.m., for after that, police patrols will prosecute for trespassing.

To get to the cemetery, take a right out of Strawbery Banke parking lot and follow the road to the fork. Bear right at the fork and continue to the cemetery on the left.

PORTSMOUTH LIGHT FORT CONSTITUTION

One of the more interesting historical haunts of Portsmouth is Fort Constitution and the Portsmouth Light. The fort was originally built in 1631 and called "the Castle," with four great guns. In 1692, it was named Fort William and Mary and expanded to nineteen guns. In 1771, a barbette battery was erected, along with the first harbor light—a shingle-sided structure with an iron light and a copper roof. In 1791, the fort was renamed Fort Constitution and was repaired and renovated. The height of the wall was doubled in 1808. By the Civil War, modern artillery had rendered the structure obsolete. All renovations and improvements on the fort stopped. The remains of the fort are part of the U.S. Coast Guard facility and can be toured by visitors daily.

A cast-iron tower that was actually built within the existing light replaced the light in 1878. The forty-eight-foot tower now stands at the harbor's edge, helping seafarers to the safety of port. The first lightkeeper, Joshua Card, held the longest tenure at the light. He retired at the age of eighty-seven in 1909 after serving thirty-five years as keeper. People would ask him what the "K" on his uniform meant, and he would steadfastly reply,

Portsmouth Light/Fort Constitution, where the ghost of a former lightkeeper still tends to his duties.

"Captain." Although Card died shortly after his retirement and is buried at the nearby Riverside Cemetery, there are some who say he is still on duty, watching over the light.

A woman visiting the light once saw a man in an old uniform standing at the door of the tower. The man then vanished into thin air. Visitors and Coast Guard staff have heard strange noises in the keeper's house. Upon investigation, they have found the quarters void of the living. Ron Kolek and his crew from New England Ghost Project (NEGP) investigated the light and found it to have a lot of energy. One of the investigators saw a form moving from the old oil house, which was otherwise secured. A sensitive with the group caught images of a man who was blown up somehow in an accident with gunpowder. It was confirmed later that a tragic explosion occurred during a Fourth of July celebration when damp powder ignited mysteriously. NEGP member and psychic medium Maureen Wood caught an image of a woman gardening just as the EMF meters began to move. When the impression faded, the meters went silent. Karen Mossey, EVP specialist, began asking if someone was there. She received an answer on the recorder: "Captain."

The light is off limits, but the fort is open daily for self-guided tours. To get to the fort follow directions for the South Cemetery, but bear left at the fork and follow the signs.

New Hampshire's Isles of Shoals

Nine islands make up what is known as the Isles of Shoals in New Hampshire and Maine. The islands in New Hampshire waters are Star, Lunging, White and Seavey. Three of these have tales that reach far beyond the imagination. Ghosts of banshees, pirates and former inhabitants embrace the folklore that has made these the most magical atolls in New England.

The islands were used as summer fishing camps by the Indians but were later discovered by John Smith in 1614, when he named them "Smythe Isles." The first European to actually disembark on their rocky terrain was Christopher Levett in 1623. The European explorers found right away that the area of the islands was ripe for shoaling, or fishing. The islands were soon renamed in honor of that fact. Permanent settlement on Hog Island came about 1660. At the time, the Massachusetts Bay Colony had reign over Hog Island and imposed a tax on the residents. They hastily dismantled their homes and rowed them to Star Island, where they would have sovereignty

from the colony. This attitude has been the paramount sentiment of "Shoalers" from the start.

The isles were home to many great historical and literary figures. Many great writers such as Nathaniel Hawthorne, Mark Twain, John Greenleaf Whittier, Henry David Thoreau and lifelong resident Celia Thaxter, who is buried on White Island, wandered and penned the legend and folklore of the minute land masses ten miles off the coast of Portsmouth. Today, there are very few residents living on the Isles of Shoals; most of them are the ghosts that have embedded themselves into the haunted history.

Pirate Ghosts, Ladies in White and Shrieking Spirits

Lunging Island is where Edward Teach, otherwise known as Blackbeard, supposedly buried some of his ill-gotten gains. Prudy Crandall-Randall heard many stories of the treasure from her father, Reverend Crandall, who bought the island in 1920. One of the ghosts that haunt the island is Blackbeard's thirteenth (some say fifteenth) wife, who was left on the island to guard the treasure after their honeymoon on Smuttynose Island in 1718. Blackbeard was caught on November 21, 1718, near Teach's Hole on Ocracoke Island, where he fought to his death with Captain Robert Maynard and his Royal Navy crew. His wife died in 1735 after waiting seventeen years for his return.

Many have witnessed the specter in a long white dress with golden locks of hair that neither sways nor tosses with the stiff sea breeze. They do not hear the seashells crunching under her steps but only the words "He will come back" permeating the ocean air. The same apparition has been witnessed on Star Island and White Island. Historical accounts show that she bounced around from one island to the next during her tenure. Some claim that the ghost is Martha Herring, wife of pirate Sandy Gordon, who settled on White Island and was blown up during a sea battle just off the atolls.

Blackbeard's ghost is also seen on the sandbar of Lunging at low tide, digging for his lost cache. Pirates frequented the islands due to the privacy and seclusion they afforded. The Shoalers loved their company and were not at all against the way the freebooters spent their money copiously while on the islands.

Star Island is also home to Betty Moody's Cave. According to legend, Moody sought refuge in the cave during an Indian raid. Her two children suffocated while she held her hands tightly over their mouths to prevent the Indians from

White Island, home of Celia Thaxter and a few loud spirits.

hearing their whimpers. Horrific screams like that of a banshee wailing can be heard in the cave as she forever mourns the deaths of her children. The howling precedes a terrible storm. Those who hear the phantom cries best take cover from the elements for the ravages of nature await them.

The White Island Light is a marvel to behold as it towers majestically from the rocky outcropping. This was once home to famous author Celia Thaxter but has long since been automated. Although no one lives on the island, the ghostly voices of two people arguing are heard bellowing in the wind. Visitors also hear footsteps along the rocks and in the lighthouse complex when no other living beings are present. The other islands are located in Maine. Look in the York Village section for more on the Isles of Shoals.

The Isles of Shoals can be visited by contacting the Isles of Shoals Steamship Company (1-800-441-4620) at 315 Market Street in Portsmouth. The trip is scenic, and you will see more than you may bargain for.

More Places of Beds, Boos, Brews and Eats

Agave Mexican Bistro
111 State Street
Portsmouth, NH 03801
603-427-5300
*There were reports of ghostly energy that roamed the building. Banging and grating sounds were heard on the second floor, which at the time was

closed. When the staff went to investigate, every stool previously on the bar had been placed upside down on the floor. A server was walking by a mirror when a hideous face appeared next to her reflection. The place has been quiet since, but time will tell.

Portsmouth Brewery
56 Market Street
Portsmouth, NH 03801
603-431-1115
www.portsmouthbrewery.com
*Since 1991, this brewpub has offered the best home brews and delicious food. No wonder the ghosts have stuck around.

Sise Inn
40 Court Street
Portsmouth, NH 03801
603-433-1200
*This 1881 Queen Anne–style home is rumored to have a few ghosts roaming its walls. Suite 204 has a presence that locks the door to the room or unlocks it at will. The ice machine on the third floor is a favorite subject of pranks for one spirit. One chambermaid was pushed into a closet by unseen hands while cleaning a room. Another staff member felt hands on her hips and, upon turning quickly around, found that she was alone in the room. The owners say these stories are made up by college kids, but you can be the judge when you spend a night in one of Portsmouth's most famous places of legend.

Wentworth by the Sea Hotel
588 Wentworth Avenue
New Castle, NH 03854
860-240-6313.
*This lavish hotel was originally built in 1873 but went through hard times until it almost crumbled to the ground. It was saved and renovated in 2003. The ghosts of the past have also renovated themselves, as music from the Roaring Twenties has been heard and spirits dressed as partygoers from that era are constantly seen walking through walls that were not present in the early twentieth century. Many staff members have left because of the ghosts, which still cling to their free and wild era.

YORK VILLAGE, MAINE
Historical Haunting on Tour

The history of New England abounds with tales and legends that helped shape our great country. Every town has a historian who recounts the remarkable moments that place that area forever in the chronicles of time. In the case of York, Maine, the historians are the ghosts that wander among the ancient village, eternally telling their story. Originally called Georgeana, York Village was chartered in 1641. It was the first town charter given to the New World by the English Crown. It was the nation's first incorporated city (1642) as well.

OLD BURYING YARD

The Old Burying Yard in York is actually the second cemetery that was implemented by the town. The first one was near York Beach, but that became quite full over a short period of time. The graves date back as far as 1700, but it has become the burying ground of significance because of its historical content and, of course, its ghosts, one of which is Mary Nasson.

Mary Nasson was a noted and respected herbalist in the community. It was because of her knowledge of healing with plants that she became known as the "White Witch." This moniker has followed her through the centuries. She was born in 1745 and grew up in York Village. It was there that she married Samuel Nasson and settled down to a life of helping others in the little hamlet. It is said that she was also a skilled exorcist who rid many houses of demons and inflictions in her time. Her time was rather short, though, as Mary died on August 18, 1774, at the age of twenty-nine.

According to records, Mary had no children. Her ghost now roams the area where she is buried. Not only has her spirit been encountered in the burial grounds, but it is seen across the street as well. Many mothers have sworn they have seen their children being pushed by an unseen force on the swings in the playground near the cemetery. When asked, the children say it

is a nice young lady named Mary who is playing with them. Any local will tell you there is nothing to fear in the spirit of Mary Nasson. Perhaps she has stayed behind to play with the children she always wanted.

Her headstone is of strange interest as well. Not only does her portrait adorn the top of the marker, but there is also a great granite slab between the headstone and footstone. Legend has it that the townsfolk put it there after she died to keep the "White Witch" from rising out of her grave. If that was the true purpose, it may not have worked as well as they planned. Actual records show that all of the graves in the burial ground were covered with a large granite slab due to the fact that the cemetery was close to farmland and the wandering livestock tended to dig up the interred. Sometime later, a wall was erected to keep the animals out, and the great slabs were taken from the graves and used to line the top of the wall. It seems that only one slab was not taken to build the wall—Mary's.

Her grave is easy to spot, as it sits alone in the far corner of the small graveyard. Since it is far away from the other stones, perhaps the builders of the wall sought the closer ones first and then were finished before they could remove hers. I tend to believe that they may have left the stone there because her husband was moving to Sanford. Each family was in charge of the upkeep of their graves, and being so far away, he would not have been able to care for the grave. It is presently the only grave in New England of such nature. People who visit the stone say it is warm to the touch. Many have sworn that they could feel the temperature rise as they put their hands on her obelisk. When I touched the grave, it was warm, despite the cool shade of a large maple tree.

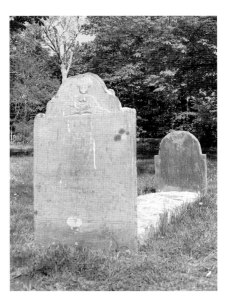

The grave of Mary Nasson, the "White Witch" of York. Note the granite slab on top of the plot. It is the only grave of its kind in New England.

Mary's legend as a witch still echoes to this day. Townsfolk even say that the crows that frequent the graveyard are her familiars. When the day is waning and the children have gone home, Mary returns to her resting place to spend the night among the dead in the Old Burying Yard.

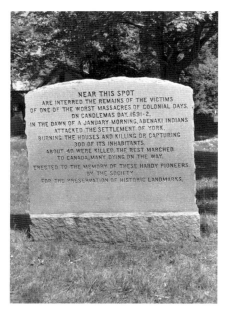

A monument to the 1692 massacre in York sits at the edge of the Old York Burial Yard.

Mary Nasson is not the only phantom of the noted cemetery. There is a monument of great historical importance that sits along the edge of the graveyard. It is here that some forty settlers are buried in a mass grave after being killed in an Indian massacre.

In January 1691–92, during Candlemas, Abenaki Indians from Canada, led by French officers, raided York at dawn. Some three hundred colonists were either killed or taken prisoner. The survivors were marched north into Canada, while the village lay in burning ruins. Every building in the village was burned or destroyed, except for three—the meetinghouse, the garrison house and the old gaol that was erected in 1656. This event was overshadowed by the witch trials in Salem later that year. History has a way of pushing aside some sagas to make room for others. The spirits of the York raid do not forget that fateful day. Moans, and even cries of anguish, can be heard at night. Strange misty figures have been seen near the common grave in both the pale glow of the moon and the light of day. They appear to be mourning the buried ones they lost so tragically. It seems that time is replaying those brutal moments that befell the village of York one horrific morning in 1692.

If you go back out to Route 1A and look to your right, you'll find two buildings of particular interest. The first is the Emerson-Wilcox House, which actually abuts the burial ground.

Two "Living" Museums

The Emerson-Wilcox House has worn many hats. It served as a stage tavern, a general store, a post office and a museum, but it started out as a simple one-room, center-chimney house built by George Ingraham, with two bedchambers on the second floor. The next owner, Edward Emerson,

decided to expand the house in 1760. He moved a circa 1710 house from another part of town and added it to the existing house, giving it the *L* shape visitors see today. A further addition in 1817 brought the number of rooms to fifteen. These rooms are furnished in period settings ranging from 1760 to 1935.

Some of the artifacts include the plans to Samuel Sewall's first pile-driven bridge, built in York in 1761; a silver tankard made in 1760 by Boston silversmith Benjamin Burt for Jonathan Sayward, York's most prominent citizen and leading Tory during the Revolution; pottery collections from 1700 to 1840; rare furniture pieces; and, my favorite, the tea table of Reverend Joseph Moody. As you might deduce, a place such as this is likely to harbor many spirits within its vast rooms—and it does.

Dana Moulton, former gaol tour guide, was a descendant of Jeremiah Moulton, a child taken in the 1692 Abenaki raid on the village. Jeremiah managed to escape and grew up to become sheriff of York Village. It was Jeremiah Moulton who rebuilt the present gaol in 1719, using timbers from the original jail (1656). It is known to be the last existing public building of the former English colonies. Jeremiah also became a famous Indian fighter. It was at his hand that Patience Boston was sentenced to death. Dana Moulton retired in early 2005, after twenty years of service, but not before telling the new carriers of the gaol torch some of his experiences. Dana told Matt Kontor and Talia Mosconi, the new tour guides, that the house next door, the Emerson-Wilcox House, built in 1742, was reputed to be haunted.

One night, while Mr. Moulton was passing by the house, he noticed a light on. When he entered the house, he heard moans and footsteps in a room nearby. He went to investigate, but the room was empty. Thoroughly spooked, he moved in haste to turn off the light. As he reached toward the switch, the light turned off by itself. He rushed out of the house, never to enter the building again unaccompanied. Even one of Moulton's dogs cowered when confronted with the idea of having to enter the house.

Talia told us that someone had committed suicide in the house. Many people have been frightened by strange moans, groans and footsteps while in the building when they were sure it was otherwise vacant.

Another reputed haunt is the Old Gaol, or jailhouse, which survived the 1692 massacre. Although it has been rebuilt from its original structure, the boards still house the spirits of those who met their fate in the walls of the jail. One of the most notable and famous ghosts of the gaol is that of Patience Boston. Patience was an Abenaki squaw who was arrested after murdering a minister's son. She drowned the boy in a well and then tried to poison the priest and his

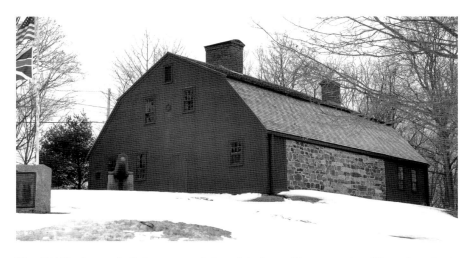

The Old Gaol was rebuilt from parts of the original one. There are a lot of legends and tales, both amusing and paranormal, regarding this historic building.

wife. It is said that the deed was done because the feisty Indian woman became uncontrollably angry at the minister's attempts to convert her to Christianity.

Patience came to the gaol pregnant, which presented an obstacle to her execution. She was granted a stay until the baby was born. Some accounts say that the baby was taken away at birth, and others say that she was allowed to wean the child until it could be adopted by another family. Either way, Patience Boston was hanged at the gallows at York Beach in 1721. She was buried in the Old Burying Yard but does not rest there. Her spirit makes its appearance frequently in the old building, which is now a museum and tourist attraction.

Tour guides are overcome with negative energy that seems to emanate from certain areas of the building. Footsteps in empty areas and moans thought to be those of the Indian squaw have scared many tourists and guides from the ancient structure. Some of the employees refuse to enter the museum alone, especially after dark. There are a lot of artifacts in the museum, which was restored in 1900 to its original eighteenth-century appearance. Some of these are also possessors of spirits long thought dead.

Old Trickey

One of York's most endearing legends is that of William Trickey. There are two versions of this story. One claims that Trickey was a pirate who

lived on the marshlands between Kittery and York. His mean and nasty nature caused him to be shunned by all. The other has Trickey arriving in the area around 1790, the same year cattle in the area died from a strange disease. Flax crop failure, corn crops withering and sheep dying followed this. Everyone immediately suspected the sea captain of bewitchery, but no proof could be found.

When "Old Trickey" died, the locals say that the devil himself came and escorted the evil soul to hell and, for punishment, made him haul sand with a rope and pail until the end of time. Trickey's Bible, now on display in the museum, will reportedly not stay open. It is said to slam shut on the hands of those who attempt to read it. Many believe it is because it was not opened enough by Mr. Trickey in life. Whatever the reason, it remains a haunted addition to the York Historical Society.

As for Old Trickey himself, well, his ghost can be seen and heard when the winds howl and the rains pelt the clapboard houses and boats of the harbor. His reverberating screams for more rope and sand send the squeamish running for cover and the fishermen quickly to safe port.

Gaol tour guides Matt and Talia were a valuable resource in uncovering the history of the village. Their wealth of knowledge was more than helpful to my cause of ghost hunting. In their first season at the gaol, they had not yet experienced any strange phenomena. They did relate some amusing historical accounts of how prisoners of the gaol were allowed to roam the unfenced jail grounds. Some roamed and never came back. One prisoner was even allowed to bring furniture from his mansion with him. During his two-year stay, he was elected town clerk of York and ran for governor of Maine.

Another reported spot for specters is the York History Museum. There are claims that this was once the town hall. Scott Stevens, executive director of the Museums of York, assured me that the "town hall has always been the town hall." The museum building resembles what might pass for a town hall, so perhaps someone surmised as much. The museum is where visitors obtain tickets to tour the homes of York. Legend has it that a young woman was hanged for witchcraft in front of the building. She cursed the town and villagers, stating that she would return to the place of her demise and haunt it forever. True to her vindictive vow, doors now open and close with no physical being to manipulate them. Items, without explanation, seem to transport themselves from one place to another. Cold spots and icy breezes send an arctic chill through unsuspecting bystanders' very souls. As if that were not enough to keep the curse going, the wraith of a woman has been seen outside the building in the spot where the accused witch was supposedly

hanged. Town offices are across the street from Jefferd's Tavern, a stone's throw away from the Museum of York headquarters.

Another spot that I feel is worth mentioning is the Stage Neck Inn on York Beach, where the gallows once stood. They say that if you sit in the lounge of the tavern, you are actually sitting right under where the gallows once swayed in the wind. Is the place haunted? No one wants to say, but I bet there are creaks in the night that are unexplainable in the realm of the living.

Handkerchief Moody

There is an even stranger side to York Village, a side labored with personal ghosts and guilt. Take the case of Reverend Joseph Moody, or as he is forever known, Handkerchief Moody.

Son of the famous Reverend Samuel Moody, Joseph Moody was born in 1700 and died in 1753. He graduated from Harvard in 1718, and in 1732, Moody became minister to the Second Church of York, Maine. After his wife died, he began to show signs of deep depression. It wasn't until he began preaching with a black veil over his face that the parishioners began to wonder about his mental condition. Still, he was always witty, logical and brilliant in his sermons, so they were led to believe that some sort of physical health-generated infliction might have created a need for the strange cloak.

Because of his appearance, the parishioners soon sought other clergy for festive occasions. It was not long before Reverend Moody became a complete recluse, save for his Sunday sermons and nightly strolls through the graveyard or along the shoreline. More and more, he sought seclusion, even from his own brothers, until he gave up preaching altogether. Many felt great remorse for the sullen figure who was now rarely seen and, when spied, sat with the black veil over his head facing the wall. He was, incidentally, the last person to speak to Patience Boston before she was hanged.

In 1753, Mr. Moody died. It was not until several years later that the truth came out about the reason for the great preacher's black cloak. Before he died, he called a fellow clergyman to his side for final confession. The reverend revealed that, many years before he became a priest, he accidentally killed his best friend while hunting. Fearing the wrath of the law, and even more the possible hatred of his friend's parents, whom he revered so, he made the deed look like an Indian attack. The villagers were convinced by his story, but his soul never healed. After that day, the spirit of his best friend always stood before him, demanding that the truth be told.

In desperation and remorse for his sins, the reverend later deemed himself unfit to look his parsonage in the face, and so he donned the cloak so that no good man should ever have to look upon the face of sin and guilt. Reverend Moody was buried next to his wife at the Old Burying Yard with the handkerchief over his face, as requested, even though he had lifted the veil in final confession.

The story of Moody's life was the inspiration for Nathaniel Hawthorne's work, "The Minister's Black Veil."

HAUNTED OR HOAX

The road that runs by the old burial ground is Lindsay Road. Follow that over Sewall's Bridge and you will see the Elizabeth Perkins House. The Elizabeth Perkins House is also reported to shelter paranormal activity. The house stands as one of the most stunning examples of Colonial Revival architecture in all of Maine. Its beautiful gables and exceptional grounds overlook the York River at one end of Sewall's eighteenth-century pile bridge. Timothy Yeales built the original house in 1686. It was called the Piggin House, not because he was unclean or raised pigs, but for some reason he named it for a small wooden vessel used for dipping from a tub. It had one stave longer than the others and was sometimes used with cream pails. A piggin was also a bowl-shaped, long-handled drinking ladle. In 1730, the owner added a center-chimney, four-room, Georgian-style home. Many owners came and went, until Mary Sowles Perkins and her daughter, Elizabeth, acquired the run-down house.

From 1900 to 1935, the two women added rooms and renovated the home to suit their own needs. The rear dining room still incorporates parts of the 1686 house. Both women were major influences in the Colonial Revival movement in York. They were also involved in movements to save many of the historical society's museums and sites. Mary died in 1929, and Elizabeth, in 1952. She bequeathed the house to the society for use as a museum. The house stands today exactly as it was at the time of Elizabeth's death. Maybe that is why she may still be occupying the place she loved so much during her lifetime.

Visitors have seen what appear to be manifestations in the house. During a tour of the house, a child pointed at a bed and said, "I see you!" She repeated the words a few more times, until the tour guide asked her what she saw. She said there was a lady on the bed wearing a wedding gown. Another visitor who was touring the home saw the woman standing at the top of the stairs. Who the ghost may be is a matter of conjecture. Some at the Old York Historical Society believe she may have wandered across the street

from the Old Stone Tavern, which is now a private residence. There were once rumors of a ghostly woman seen standing at the top of the stairs there. More popular belief is that it is Elizabeth watching over her valuables in the home that was named after her. Many seem to think that Elizabeth made up the stories herself to generate an influx of visitors to the home. Maybe she is still there, trying to validate her claims that her house was haunted. Take a tour of the house and ask the ghost—you might just get an answer.

REVEREND BURROUGHS
The Witch

Witch Trot Road would be a weird name for a thoroughfare anywhere but in New England. There are a few legends surrounding the name of the road, which is reported to be extremely haunted. Local lore says that this is the road accused witches traveled on their way to the gallows. Now, their forms can be seen in the dead of night, wandering along the lane, seeking revenge for their injustice. According to *The Old Town of Berwick* by Sarah Orne Jewett, the name comes from an incident involving Reverend Burroughs of Wells, who was accused of witchcraft during the height of the Salem Witch Trials. An enemy of his in Danvers, where he had once preached, accompanied two constables in making sure that the accused witch was brought to justice. Burroughs, a strong and clever man, knew his fate and decided to give his accuser a run for his money. They found Burroughs at his parsonage, and the pastor agreed to prove his innocence in front of the magistrate in Danvers, but they would take a shorter circuit than the one that brought them to his door, along the old post road through York. The men later believed that the witch enchanted them and brought them to a dark forest bedeviled with the evil throes of nature. They came to a strange high ridge as the sky grew dark and thunderclouds rolled in overhead.

The three lawmen became frightened out of their wits, for they believed the man had summoned the powers of the devil against them. Lightning struck on all sides as the horses flew in fear, yet the shadow of Burroughs in the flashing light remained calm and steady in his manner. The party hurried through the hilly terrain as the tempest grew worse. Surely they felt they would perish as they rode along what from that night on would be called Witch Trot Road. Soon, the storm subsided, and Reverend Burroughs remained undaunted in his trek to Salem. Looking at my records, I notice that a George Burroughs from Wells was arrested on April 30, 1692, and executed for witchcraft on August 19

of that year. The story is the same, and the result is history—a history that gave a road its name and a town a moment in time that it will never forget.

MOUNT AGAMENTICUS
A Saintly Mountain

This 690-foot-above-sea-level peak has been a ski slope, a recreation area and a biking trail. The local Indians knew it as the place where the great "Praying Indian" St. Aspinquid is buried. The mountain is said to be sacred to the Indians, who settled at the base of the hill. The story of Aspinquid, if at all true, has many different versions. Most scholars believe it is based loosely on the life of Chief Passaconaway, a remarkable Indian leader whose name, roughly translated, means "son of the bear."

Aspinquid was known to spread Christianity from coast to coast, and his healing powers were remarkable. It is written that he was born in May 1588 and died in May 1682. Thousands of Indians attended his funeral, and over six thousand animals were supposedly sacrificed. There is a monument to Aspinquid on top of Mount Agamenticus detailing the legend. Whatever facts prevail as to who Aspinquid was, the mountain is now a preserve with ten thousand unspoiled acres, offering hikers and mountain bikers a chance to see the wonders of the region.

John Cabot may have discovered the mountain in 1497, but it is Captain John Smith who put the peak on the map, calling it Sandown Hill on his now famous *Map of New England*. Take a hike or a drive to the top and read the legend. It is one of New England's truly magical places.

Take I-95 North into Maine. Take Exit 7 toward York. Follow signs to Route 1 North. Turn left onto Route 1 North. Turn left onto Mountain Road. There is a gravel parking lot on the right and a paved road leading to the summit of Mount Agamenticus. Turn right and drive up to the summit, or park in the gravel lot to hike up. Trail maps are available at the trailhead.

THE NUBBLE LIGHT

York Beach in Maine boasts the most beautiful lighthouse in all of America. I am not saying this simply because I saw it myself and thought it was breathtaking. There are countless people who arrive every day at Cape

Nubble Light in York has an air of magic about it. As seen in the photograph, it is a beautiful, haunting structure.

Neddick to take pictures of this stunning piece of scenery. As a matter of fact, it is the most photographed lighthouse in America. But do not let the magnificence of architecture fool you. Lying amidst the small rocky crag on which the beacon sits are a few ghosts.

The lighthouse was built in 1879 on the small island that is just off the tip of the Cape Neddick peninsula. As with most lighthouses, it is mostly self-sufficient. A series of drain spouts run from the roof to catch drain water and direct them into a cistern in the basement. There is a ski lift that transports passengers and items from the mainland to the light. The house itself is much like a dollhouse, with its gingerbread trimming and quaint front porch. The gables face in the directions of the four compass points so that planes flying by can use the building for quick navigation.

Before the lighthouse was put into place, a shipwreck at Nubble Island claimed the lives of the captain and crew of the *Isidore*. It was Thanksgiving 1842 when the 396-ton bark sailed out of Kennebunkport bound for New Orleans. Captain Leander Foss charted his course using nearby Boon Island as a checkpoint. The ship did not get far. The winds from the north came swiftly, and a storm of magnificent proportions ensued. No one knows what happened for sure, but the next morning, remnants of the *Isidore* were washing up onshore, along with thirteen bodies. There were no survivors. Since that fateful night, witnesses have seen the large ghost ship sailing past the Nubble Light, with its phantom crew looking over the side as it heads south on its eternal journey.

There is an interesting tale that accompanies the wreck of the *Isidore*. One crewmember, Thomas King, had a dream that the ship was going to meet disaster. When it came time to sail, he hid in the woods nearby. Since he had

been paid for the journey, the captain ordered the crew to find the wayward man. He stayed under cover until the crew gave up looking for him and sailed off without him. In theory, he was the only survivor of that tragic incident at sea.

Not all spirits of the sea are foreboding entities. It seems that the Nubble Light has positive energy attached to it as well. Many who have visited the light claim to have felt a force that is comforting and encouraging. There are some who have actually had their lives changed for the better after visiting the magical building. After visiting the lighthouse with my wife, we both can see why. If you are standing on the cliffs overlooking Nubble Island and see a ghost ship pass behind the lighthouse or feel a breath of refreshing energy revitalize you, it is certain that you will never forget the experience.

To get to the light, follow Route 1A to Nubble Road. The light is at the end of the road.

Boon Island
The Ominous Light

Boon Island is a small rocky outcropping several miles off the coast of York Beach in Maine. The forlorn projection sits ominously, awaiting the unwary sailor who might steer into its path. The island got its name in 1682, when the *Increase* slammed into it. Four survivors were rescued when someone saw smoke signals coming from the fourteen-foot-above-sea-level land mass. The survivors saw the sparing of their lives from the ruthless sea as a boon from God. Nineteenth-century lighthouse superintendent and acclaimed author Samuel Adams Drake penned many paragraphs pertaining to the desolate atoll and its perilous location, describing the rock as that of an inescapable prison when the tempests wreak havoc on the rocky outcropping. Thus, those who choose to keep the light that looms above the stone are always subject to the perils of the untamed sea.

On December 11, 1710, the *Nottingham Galley* crashed into Boon Island. Two crewmembers died on impact, and the remaining band wrestled with the elements in an attempt to survive. The surviving crew resorted to cannibalism after three weeks on the island. After their rescue, provisions were frequently put on the island to prevent future casualties of possible shipwrecks. Recently, nine cannons were found near the island that belonged to the *Nottingham Galley.*

In 1797, lighthouse superintendent General Benjamin Lincoln convinced the Boston Marine Society to put a beacon on Boon Island. President

John Adams agreed, and in 1799, an eighty-foot beacon was erected for the hefty price of $600. Being a lighthouse keeper in those days was a job many wanted, but in the case of Boon Island, tending to the beacon was unnerving. On several occasions, storms destroyed the light before it was totally swept away during a gale in 1804.

In 1805, a stone beacon was erected for permanent safety, but the curse that had set itself into the stone was there for good. Several of the workers drowned in a boating accident shortly after leaving the island. According to Celia Thaxter, author of the book *Among the Isle of Shoals* (1873), a man related to her how he had grown up on the island and once found some bones among the rocks. When he brought it to the attention of his parents, they told him how the workers capsized while attempting to leave the barren rock. One body washed ashore near Plum Island, while the surviving worker buried the others on Boon Island and covered their remains with many rocks that have since washed into the sea. The remains were moved to York for proper burial, but perhaps their spirits still linger, looking for a way home.

The new light did not last very long. It, too, submitted to the raging sea. In 1811, President James Madison ordered that a more stable and permanent light be erected on Boon Island. It stood only thirty-two feet high. Because of the dangerously low level of the island, the first lightkeeper lasted about two weeks. He claimed that the waves washed completely over the light and that it was sure to disappear in the next storm. By 1831, the island was barren of a light once again due to the storms and north winds of the Atlantic.

In 1852, building commenced on the final light. By January 1, 1855, a 103-foot masonry tower lit the way for mariners to steer clear of the island. The cost of the tower and lamp was an astonishing $44,973. As the light gleamed in the night, so too did the dark curse that the island had nurtured. There is a legend of a lady in white who roams the little island. Fisherman and visitors, as well as keepers of the light, have seen the melancholy spirit along the rocky rim of Boon Island.

She is said to be the spirit of a young lightkeeper's wife. The young couple had recently married when he accepted the position as lightkeeper on Boon Island. The remote location of the island became their Eden, until the groom became ill. The young bride knew that someone would be out to check on them soon, but unfortunately a great storm kicked out of the north and the gale-force winds held all sea travel at bay for several days.

The husband suddenly took a turn for the worse and died during the brunt of the storm. His grieving wife could only keep the light lit and wait

for the storm to pass. For a week, she constantly ascended the 168 steps to the light, carefully trimming the wick and keeping the light burning in a valiant effort to warn any wayward ships of impending doom.

The storm soon passed, and the people on the mainland noticed that the light was not lit. Rescue crews rowed out to the dreaded island and found the groom dead and the bride too ill to go on. She died shortly after. Her ghost, to this day, watches over the ships' passing as she faithfully keeps the light safe.

To get to Boon Island, you must take a boat or take an Isles of Shoals steamship out of Portsmouth,. You may also contact Bigger N' Better (800-526-8172) charter boats at Town Dock #2 in York. You can also see the light on a clear day from Cape Neddick.

MAINE'S ISLES OF SHOALS
More Tales of Pirates and Spooks

Phillip Babb Still Roams

Appledore Island is the largest of the Isles of Shoals. It spans ninety-five acres, measuring one mile from east to west and six-tenths of a mile from north to south—not a lot of room to roam, but enough for one eternal spirit of the atoll, Phillip Babb, to make his rounds. Some say that Babb was a pirate, having sailed with Captain Kidd, but Babb died long before Kidd's adventures on the high seas began. It is also rumored that he was the famous Don Pedro, who gave Ocean Born Mary her name, but he died on March 3, 1671, long before Mary Fulton was born. If he was a pirate, he kept it to himself.

Babb was born in 1634 in England. His family immigrated to the New World and settled on Appledore, where he later ran an inn, was constable and had a butcher shop. He and his kin are buried on the island. His ghost, however, is not at rest. Many have seen the shadow of Babb, dressed in a butcher's frock and sporting a gargantuan knife, roaming among the atoll. One moonlit night, a man was sitting on the porch of his cabin when he spied a burly shadow moving up the path toward him. When the figure got close enough, he recognized Phillip Babb. The wraith had black sockets for eyes and a large knife in his belt. The man called out to the ghost, but the entity kept walking silently along the path until the man could no longer see it.

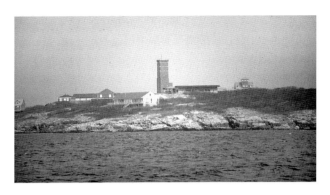

Appledore Island, home of the wicked Phillip Babb, who still roams the atoll centuries after his death.

Another resident met the angry ghost of Babb face to face, and this time, the spirit drew his knife and brandished it in the frightened man's face. This was more than the islander needed to see before he ran for the safety of his cabin. Others have spied the angry apparition on the ledge of Babb's Cove as if in search of something, perhaps a buried cache of riches. There was once a great hole thought to be where the eternal wandering spirit of Babb was digging for treasure, but the hurricane of 1938 filled it in. After that, the Coast Guard built a house where the pit was, forever covering whatever might have been there.

A Vengeful Phantom

There is another eternal wanderer of the isles that appears when the fog is thick and the night is ripe for haunts. A phantom dory haunts the waters, looking for Guinea boats that may be moored along the docks of the islands. Legend has it that a fisherman from one of these Guinea boats came ashore and killed an islander's wife. The boat then set out to sea. When the husband of the woman returned, he was arrested for the crime but escaped during a tempest in a small dory, never to be seen again; that is, until the Guinea boat returned. One night, there was a bloodcurdling scream from below deck as the boat was docked among the islands. When the anglers rushed below, they saw the man who had murdered the woman months before lying on the deck with his hand severed.

After this incident, no Guinea boat was safe from the vengeful phantom in the dory. Crewmembers would have their limbs chopped, their eyes pulled out of their sockets or their ears lopped off. Each time, the sound of oars swishing in the water could be heard as the ghostly boat slithered away into the abyss. Soon, the Guinea boats became phantoms of the waters around the shoals, as no crew dared provoke the curse. The phantom dory still makes

its rounds on stormy nights, when the fog is thick and the boats are moored, looking for more victims to take revenge upon.

Smuttynose: First Boos, Now Brews

Smuttynose Island has an illustrious history ripe for the haunting. Captain Sam Haley Jr. lived on the island, which was named after its rock profile, in a small cabin that his father, Sam Haley, may have built. He kept a lit candle in the window to warn mariners of the rocky outcroppings. The cabin still stands to this day and is the very same one that graces the label of the famous Smuttynose Brewery products.

In January 1813, a ship wrecked on the rocks, and Haley supposedly buried fourteen Spanish sailors. Popular literature states that it was the *Sagunto*, but Haley recorded the ship as the *Conception* out of Cadiz, Spain. The *Sagunto* reportedly reached safe harbor in Newport during the same storm. Do the Spanish sailors haunt the island? No one has ever reported so. The island is said to be haunted by the spirits of Anethe Matea and Karen Ann Christensen, who were murdered while staying with the Hontvets. The Hontvet house burned in 1885, but the foundation still remains not far from the Haley house. Some claim it is Louis Wagner, the man who was hanged for the murders, who haunts the island. Perhaps it is the ghost of Sam Haley Jr. or his father, or both. Whatever the case, someone plays with doors, makes a lot of noise and bangs around the buildings of Smuttynose. Whoever it is, they sure know how to make a stay on a secluded island a lot more interesting.

The islands can be reached by boat. See Portsmouth for details.

WHERE TO STAY

Places to stay in York are abundant and provide a full spectrum of rates and accommodations. From a motel to a bed-and-breakfast, there is something for everyone. Some lodgings, however, you may have to share with an occupant from the other side. Here are a few to get you going:

The Inn at Tanglewood Hall Bed & Breakfast
611 York Street (Route 1A)

York, ME 03911
201-351-1075
*Tanglewood Hall is a wonderful Victorian bed-and-breakfast with scenic vistas and ocean views. This enchanting summer estate was built in 1889 by Chicago lumber baron Alexander Coburn Soper and his wife, Mollie Ezra Pope. They owned it for fifty years. At some point; the York Historical Society acquired it and turned it into a decorator show home. Su Wetzel now has the keys to this timeless six-room inn, with beautifully appointed private rooms and breathtaking scenery, gardens and woodlands. This is close to the haunted places of York Village and has also had some reports of spirit activity. Guests have felt a presence at the inn and have also photographed orbs at various times. No one has felt any malevolence—just curious spirits welcoming those who will be spending the night at their former home.

The Candleshop Inn
44 Freeman Street
York, ME 03911
201-363-4087
www.candleshopinn.com
*Barbara Sheff of the Candleshop Inn has had investigators search for spirits at her bed-and-breakfast, and indeed, there are two. There have been a few occasions in which guests have approached her about some paranormal activity they experienced. The house is a combination of three houses that were put together in 1896 and includes ten guest rooms. Parts of the house date back to the 1700s. It has become a premier holistic retreat where guests are served a hearty vegetarian buffet-style breakfast and then attend yoga classes on the beach. Reiki, therapeutic message and aromatherapy are also available. One might want to get in touch with higher powers in the Japanese meditation garden as well. It is a comforting and relaxing place where guests can be spiritual with the spirits.

Follow Route 1A out of York Village, past Nubble Road and the Nubble Light, and take a right onto Freeman Street.

CONCLUSION

This guide will hopefully be a road to adventure that the reader has never before experienced. Between the time of this writing and the reader's embarking along the ghostly trail, some of the places may disappear or close. This is inevitable, as even the spirit world is prone to the iniquity of progress and time. There may be other places that join the ranks of those mentioned in this tome. When journeying through these destinations, never feel sheepish to ask about the haunts of the region, for they are the lasting history that stays alive in both soul and spirit.

BIBLIOGRAPHY

Belanger, Jeff. *Encyclopedia of Haunted Places*. Franklin Lakes, NJ: New Page Books, 2005.

Bolte, Mary, and Mary Eastman. *Haunted New England*. Riverside, CT: Chatham Press Inc., 1972.

Cahill, Robert Ellis. *Haunted Happenings*. Salem, MA: Old Saltbox Publishing House, 1992.

————. *Lighthouse Mysteries of the North Atlantic*. Salem, MA: Old Saltbox Publishing House, 1998.

————. *Mountain Madness*. Peabody, MA: Chandler-Smith Publishing House Inc., 1989.

Citro, Joseph. *Ghosts, Ghouls, and Unsolved Mysteries*. New York: Houghton Mifflin Company, 1994.

————. *Green Mountain Dark Tales*. Hanover, NH: University Press of New England, 1999.

D'Agostino, Thomas. *Abandoned Villages and Ghost Towns of New England*. Atglen, PA: Schiffer Books, 2008.

————. *Haunted Massachusetts*. Atglen, PA: Schiffer Books, 2007.

————. *Haunted New Hampshire*. Atglen, PA: Schiffer Books, 2007.

————. *Haunted Rhode Island*. Atglen, PA: Schiffer Books, 2006.

————. *Pirate Ghosts and Phantom Ships*. Atglen, PA: Schiffer Books, 2008.

Drake, Samuel Adams. *New England Legends and Folklore in Poetry and Prose*. Boston, MA: Little, Brown and Co. 1883.

Emmerton, Caroline O. *The Chronicles of Three Houses.* Salem, MA: House of Seven Gables Settlement Association, 1935.

Greene, J.R. *Strange Tales of the Quabbin.* Athol, MA: Highland Press, 1993.

Mallett, Rene. *Ghosts of Portsmouth, New Hampshire.* Atglen, PA: Schiffer Books, 2009.

Myers, Arthur. *The Ghostly Register.* Chicago: Contemporary Books, 1986.

Ramsey, Floyd W. *The Willey Slide.* Littleton, NH: Bondcliff Books, 2003.

Rooney, Ashley E. *Berkshire Ghosts.* Atglen, PA: Schiffer Books, 2008.

Sharp, Elyne Austen. *Haunted Newport.* Newport, RI: Austen Sharp, 1999.

Smitten, Susan. *Ghost Stories of New England.* Auburn, WA: Lone Pine Publishing, 2003.

Thaxter, Celia. *Among the Isles of Shoals.* Lebanon, NH: University Press of New England, 2003.

Varney, George. *History of York, ME: From a Gazetter of the State of Maine.* Boston: B.B.Russell, 1886.

Williams, John. *The Redeemed Captive Returning to Zion.* Cambridge, MA: Applewood Books, 1987.

WEB RESOURCES

www.berkshires.org

www.ghoststoriesofamerica.com

www.ghostvillage.com

www.hauntedaccommodations.com

www.masscrossroads.com

www.mohawktrail.com

www.mystic.org

www.newenglandghostproject.com

www.shadowlands.com

www.visitwhitemountains.com

www.yankeeghosts.com

www.yorkmaine.org

ABOUT THE AUTHOR

Thomas D'Agostino has been extensively studying and investigating paranormal accounts for over twenty-seven years. Creator of several books with his wife, Arlene Nicholson, together they have penned and captured on film the best haunts and history New England has to offer.

Other stories and accounts are featured in *Ghost Stories of New England*, published by Lone Pine Publishing, and *The Encyclopedia of Haunted Places*, by Jeff Belanger, published by New Page Books. Tom is also a regular contributor to *FATE* magazine.

The *Providence Journal Bulletin*; the *Rhode Island Monthly*; *What's News*, the second-largest circulation in the state of Rhode Island; the *Northwest Neighbors*; the *East Providence Post*; the *Valley Breeze*; the *Call*; the *Boston Globe*; *Reminder News*; the *Norwich Bulletin*; the *Foster Daily Democrat*; the *Rochester Times*; *Smithfield Magazine*; *Stateline Review*; and the *North Adams Transcript* have run stories and interviews on Tom and Arlene's history of paranormal investigations.

Television appearances include: *Ghosts Are Near*, Episodes 6, 27 and 29; Rhode Island PBS, September 2008; and *Things That Go Bump in the Night:*

Tales of Haunted New England, WGBY, 2009. Tom also co-wrote, co-produced and performed the musical score for *Ghosts of Foster, Rhode Island* for Cox Communications in 2008.

Radio shows include: *Preston Dennett-UFOs and the Paranormal*, *X-Zone Radio Show*, *Night Watchman Chronicles* (two shows), *After Twilight*, *Ghostly Talk* (two shows), *Ghost Chronicles* (three shows), KZUM Radio (2 shows), Shallow Graves Radio, Ghost Village Radio, *Spooky South Coast* (three shows), WINY 1350 AM and WORC 98.9 FM.

Tom has also written accounts of haunted places throughout New England for the International Ghost Hunters Society, HauntedPlaces.com, Shadowlands.com and Ghosttowns.com. He is a member of or contributor to all of these organizations.

Tom is a graduate of Rhode Island College with a degree in political science and a minor in music and business. Together, Tom and Arlene co-organized the Paranormal United Research Society, a coalition that includes some of the best paranormal researchers in New England and beyond. They presently reside in Connecticut.